POSTCARD HISTORY SERIES

Austin

ON THE COVER: This 1930s image of Congress Avenue looking north shows the mix of commerce and state government that help explain why Congress Avenue is called "The Main Street of Texas." The Scarborough Building (1910) is on the left, the Littlefield Building (1911) is on the right, and the landmark state capitol is in the distance. (Published by E. C. Kropp Company, Milwaukee.)

ON THE BACK COVER: This image of the University of Texas "Old Main" building is unfamiliar to most readers today. Old Main (designed by architect Frederick Ruffini) housed administration offices, classrooms, and a library and was located at the top of a hill in the center of campus. It was the first building erected at the University of Texas and was quite impressive for its time. In 1935, however, it was razed to make room for a new administrative building and library that includes the now-familiar UT Tower building. (Published by Abe Frank Cigar Company, Austin, and C. T. American Art.)

POSTCARD HISTORY SERIES

Austin

Don Martin

ARCADIA
PUBLISHING

Published by Arcadia Publishing
Charleston SC, Chicago IL, Portsmouth NH, San Francisco CA

Printed in the United States of America

Library of Congress Control Number: 2008936542

For all general information contact Arcadia Publishing at:
Telephone 843-853-2070
Fax 843-853-0044
E-mail sales@arcadiapublishing.com
For customer service and orders:
Toll-Free 1-888-313-2665

Visit us on the Internet at www.arcadiapublishing.com

To Aaron, Clara, Cameron, and especially Ronna,
who have all shown tremendous patience
with my many and varied "collection" passions over the years.

CONTENTS

ACKNOWLEDGMENTS

There are many people to thank for their assistance in this project. At the Austin History Center (AHC) are Mike Miller, executive director; Daniel Alonozo, photo curator; and Grace McEvoy, who kindly scanned for me the postcards from the AHC that are included in this volume. Also thanks to "History Detective" Phoebe Allen.

I owe deep gratitude and a debt to Waneen Spirduso for sharing her postcard collection with me, sharing her advice, and allowing me to scan cards that filled out missing sections. Spirduso also helped with missing research and shared her amusing and insightful stories of growing up in Austin and her knowledge of the University of Texas. Also, thanks to Ned Coleman and the Capital of Texas Postcard Club.

Regarding publications, I used several different ones in my research (see the bibliography), but two were of particular value: *Austin, An Illustrated History* by David C. Humphrey and William C. Crawford Jr. and *Austin, Texas Then and Now* by Jeffrey Kerr. Also *UT History 101*, by Margaret C. Berry, was invaluable regarding the University of Texas. I highly recommend all of them to you. Perhaps most important of all is the Internet edition of the *Handbook of Texas On-line*. Whenever I got stuck and could not find information, I could usually count on the *Handbook of Texas* to come to the rescue.

I also want to thank Claude M. Gruener for his meticulous edits and patience in reviewing my work and his many helpful suggestions. Also thanks to Bill and Susan Smalling for suggesting that I write a book. Thank you also to my editor at Arcadia, Kristie Kelly, for her help and encouragement. A special debt of gratitude is owed to my parents for igniting my curiosity and interest in collecting everything from fossils to Native American artifacts, rocks, and minerals. And lastly to my wife, Ronna, who has put up with my varied collecting passions over the years. You have shown remarkable patience and I love you for it.

If there are mistakes in the manuscript, and there undoubtedly are, the mistakes are mine alone. I hope you will drop me a note and let me know.

—Don Martin
(P.O. Box 162506, Austin TX 78716)

INTRODUCTION

Welcome to Austin, Texas's history as told through postcards. Unfortunately, only a portion of the city's interesting history can be told in this manner. After all, postcards did not come onto the scene until 1898 (then called Private Mailing Cards), and the history is limited to those cards that can still be found and collected.

Instead what follows is an interesting glimpse into Austin's past. It is not meant to be inclusive, but rather it shows an interesting side to Austin recorded through the photographs and illustrations on postcards sold at roadside stands, gas stations, and in department stores.

The study and collecting of postcards is called deltiology. Deltiology is the third largest hobby after stamp collecting and money collecting. Compared to philately (stamp collecting), the identification of a postcard's place and time can often be a near impossible task. Postmarks of course can help date used postcards, and those with postmarks are noted in this book. Postcards are also collected by historical societies, libraries, and genealogical societies because of their importance in research, such as how a city looked at a particular time in history as well as social history.

To help with dating postcards, it is helpful to know a general timeline:

PRIVATE MAILING CARDS (1898–1901)
Beginning May 19, 1898, printers were allowed to print the first postcards, called Private Mailing Cards, with the required wording "Authorized by an Act of Congress—May 19, 1898." The back was used strictly for the address only, with occasionally a small blank area on the front (the picture side) for any message. Many were embossed and color printed and were often printed in England or Germany.

REAL-PHOTO POSTCARDS (RPPCS) (1900–PRESENT)
Beginning about 1900, these cards involve the use of a real photograph printed on photograph paper, with a pre-printed back used to form a postcard. They are particularly difficult to date unless they have a postmark or a date from the photographer, but they provide a one-of-a-kind or limited number of images as opposed to printed images and are valued collectibles.

UNDIVIDED BACK (1901–1907)
Starting December 4, 1901, publishers were allowed to use *Postcard* or *Post Card* on the back, but still no writing was allowed on the back (opposite the picture side) except for the address.

DIVIDED BACK (1907–1914)
Starting on March 1, 1907, postcards could be printed with a vertical line on the back providing an area for the address, and the area to the left was used for a written message.

WHITE-BORDER ERA (1917-1930)
During this period, cards were sometimes printed with a white border around the picture to save ink and printing expenses because of World War I. The quality of cards during this era is often not up to par with earlier standards. Often the cards were printed in black and white.

LINEN CARDS (1930–1945)
The Curt Teich Company (also Curteich, C. T., and C. T.-Colortone) inaugurated an era of vibrant color cards printed on a linen-textured paper stock typically with a high rag content. Photographs were airbrushed and color enhanced for visual appeal. Other publishers quickly followed suit. These types of cards were very popular at the time and are very popular with collectors today.

PHOTOCHROME (1939–PRESENT)
Photochromes, also known as "modern chromes," are in color and are professionally printed on glossy paper stock. Their spread was momentarily slowed during World War II as a result of supply shortages, but they had replaced both linen and black-and-white postcards by 1945 and are typically what is used today.

One

CONGRESS AVENUE AND DOWNTOWN

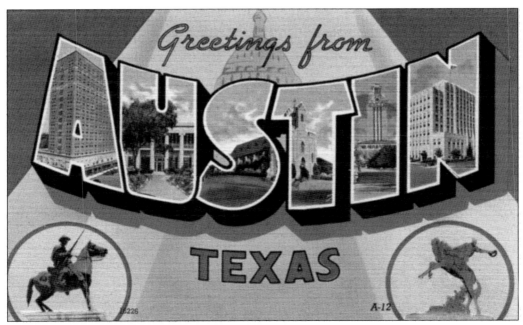

GREETINGS FROM AUSTIN, TEXAS. Large letter cards like this are themselves a specialty among postcard collectors. This card is one of the more interesting ones featuring Austin and seems like as good a place to start a book on Austin postcards. Chapter one will feature scenes from Congress Avenue and downtown Austin. (Published by Colourpicture, Cambridge, Massachusetts, and Hausler-Kilian Cigar and Candy Company, Austin.)

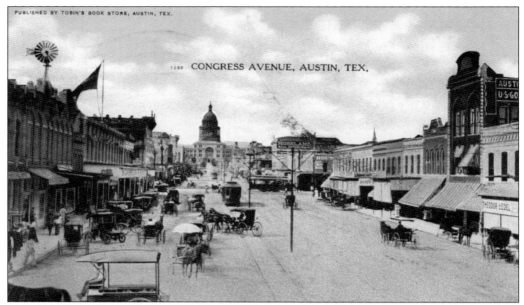

CONGRESS AVENUE, AUSTIN, TEX,

MAIN STREET OF TEXAS, POSTMARKED 1903. Known as "the Main Street of Texas," Congress Avenue runs from the Colorado River (and beyond) in the south and north to the state capitol. At one point in time, one could drive a car, ride a horse-drawn carriage, or use the electric streetcar to travel the avenue. On the reverse, the writer says, "This is the widest and most beautiful street in the State of Texas." (Published by Tobin's Book Store, Austin.)

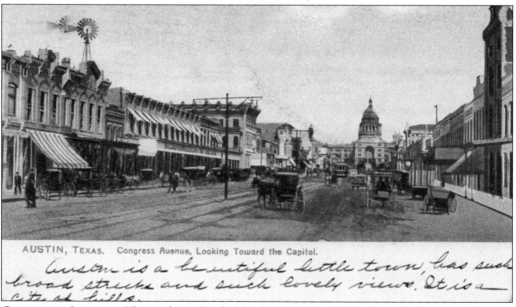

AUSTIN, TEXAS. Congress Avenue, Looking Toward the Capitol.

CONGRESS AVENUE. This early undivided-back postcard scene is from the horse-and-buggy era, yet the electrical streetcar is already in use as well with the overhead electric lines running down the middle of Congress Avenue. Scarborough and Hick's department store is on the left. The windmill on the left is unusual to see in a city setting. (Published by Raphael Tuck and Sons, Austin.)

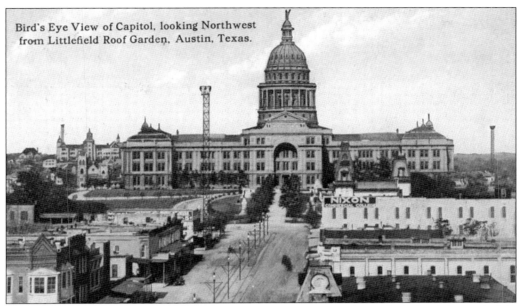

Bird's Eye View of Capitol, looking Northwest from Littlefield Roof Garden, Austin, Texas.

MOON TOWERS. Congress terminates here at the state capitol. To the left of the capitol in the background is the "Old Main" building of the University of Texas. Note that there are three barely visible "moon towers." Thirty-one moon towers (each 165 feet tall) were installed around the city and connected to their own generators at the Colorado River dam to provide nighttime lighting in Austin. (Published by Abe Frank, Austin.)

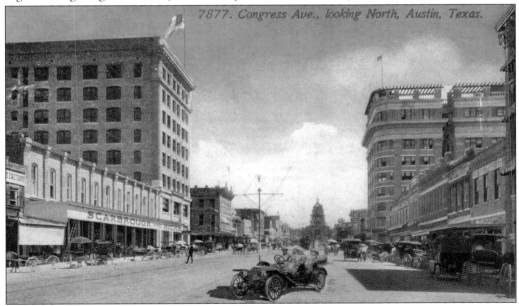

7877. Congress Ave., looking North, Austin, Texas.

CONGRESS AVENUE AUTOMOBILES. Soon automobiles began to replace the horse and buggy (shown here are automobiles, buggies, and horse-drawn wagons). In 1905, Congress Avenue was paved with bricks, mostly from the Thurber Brick Works in Thurber, Texas, to accommodate the increasing number of automobiles. Paving began soon thereafter on other downtown streets as well. (Published by Sauter and Kuehne, Austin; Waneen Spirduso collection.)

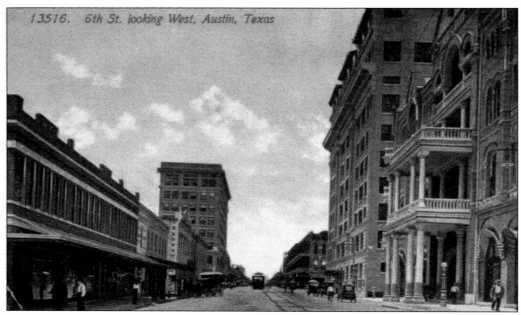

STREETCAR LINE. In 1890, Monroe M. Shipe (the developer of Hyde Park) secured a city charter to build an electric streetcar line starting on Congress Avenue . . . and later, of course, serving Hyde Park. In this undivided-back postcard, the streets are not yet paved. The scene is looking east on Pecan (Sixth) Street at Congress Avenue. (Published by Leipzig, St. Louis; Waneen Spirduso collection.)

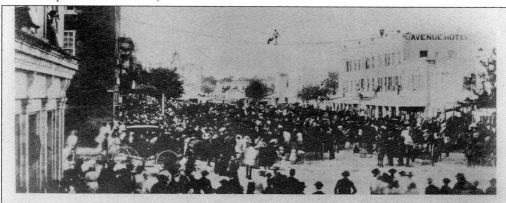

TIGHTROPE WALKER (UNDIVIDED BACK). One of the more unusual early scenes on Congress Avenue was French tightrope walker Jean Devier walking above the avenue on a rope suspended between two brick buildings without a net. At one point, he pushed a wheelbarrow across the street and back. A large crowd turned out on May 10, 1867, to witness the "death defying" spectacle. (Publisher unknown; Austin History Center, Austin Public Library.)

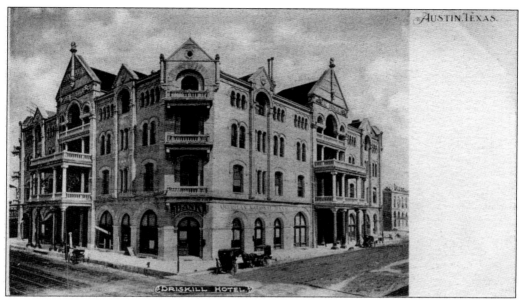

DRISKILL HOTEL (UNDIVIDED BACK). When the four-story Driskill Hotel opened in 1886 on Pecan (Sixth) and Brazos Streets, it was the most spectacular hotel in Texas. Built by cattle baron and real estate investor Col. Jesse Lincoln Driskill, it was a showplace of Texas hospitality boasting 60 steam-heated rooms, a barbershop, a magnificent sky-lit dining room, and elaborate ballrooms. (Publisher unknown; Austin History Center, Austin Public Library.)

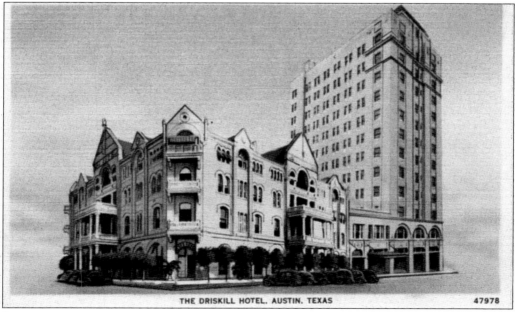

DRISKILL HOTEL ANNEX. In 1930, a 13-story annex was added to the famous hotel, providing considerably more room capacity. Over the years, the hotel changed hands numerous times and underwent several renovations. In 1970, the Heritage Society of Austin mounted a successful campaign to interest private investors to save and rehabilitate the building. A full restoration ensued. (Published by Ellison, Austin.)

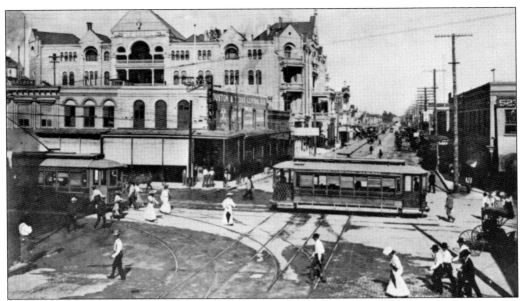

SIXTH STREET AND CONGRESS AVENUE, LOOKING EAST. The intersection of Pecan (Sixth) Street and Congress Avenue was unquestionably the bustling center of commerce in Austin. This shows Pecan at Congress looking east with streetcars at the intersection. The Driskill is on the left (north) side of Pecan, but the Littlefield Building (1910) has not yet been built. The electric streetcars served Austin for approximately 50 years. (Reprint published by and © Austin History Center Association, Austin.)

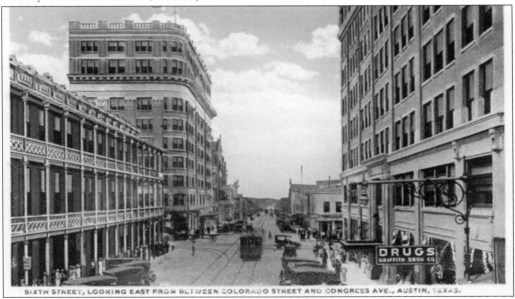

SIXTH STREET, LOOKING EAST FROM BETWEEN COLORADO STREET AND CONGRESS AVE., AUSTIN, TEXAS.

SIXTH STREET AND CONGRESS AVENUE, LOOKING WEST. Just 10 years later, the look of the intersection has changed dramatically. This view is looking west on Pecan (Sixth) Street. The streets are now paved, and the Scarborough Building (left) and Littlefield Building (right) have been constructed on opposite corners of Pecan Street and Congress Avenue. The two buildings were the first "skyscrapers" in Austin. (Published by Abe Frank, Austin, and C. T. American Art.)

SCARBROUGH BUILDING, POSTMARKED 1916. This eight-story building at the southwest corner of Pecan (Sixth) Street and Congress Avenue was built in 1910 and was considered the first "skyscraper" in Austin, quickly followed by the Littlefield Building. Both buildings used a steel-frame construction, allowing for the first tall edifices in Austin. The Scarbrough and Hicks department store occupied the first two floors, and the rest was office space. (Published by Abe Frank, Austin, and C. T. Photochrom.)

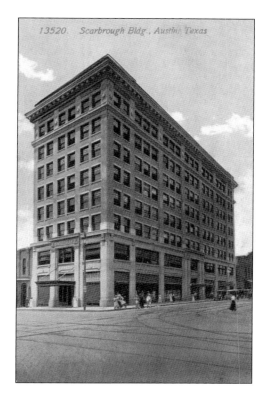

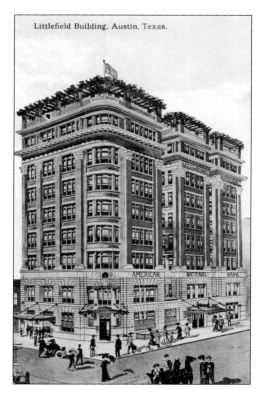

LITTLEFIELD BUILDING. From a meager beginning, George Washington Littlefield rose to become a highly successful entrepreneur-businessman as a cattleman, rancher, land speculator, and banker. He also served as a member of the UT Board of Regents. In 1890, he organized the American National Bank and in 1910–1911 constructed the eight-story Littlefield Building at the northeast corner of Pecan (Sixth) Street and Congress Avenue. The first two floors housed the bank and the rest was office space. Like other buildings of its time, there was no air-conditioning. (Published by Abe Frank, Austin, and C. T. Photochrom.)

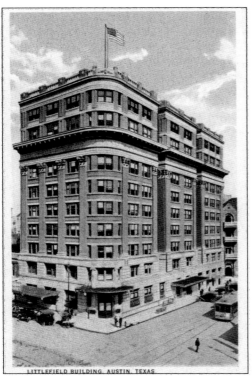

LITTLEFIELD BUILDING, AUSTIN, TEXAS

LITTLEFIELD BUILDING—ADDITIONAL HEIGHT. When first constructed, the Littlefield Building was the same height as the Scarborough Building across the street. However, in 1915, four years later, the arbor area was removed from the roof and an additional floor was added, making it the tallest building in Austin and securing bragging rights for George Washington Littlefield. (Published by Abe Frank, Austin.)

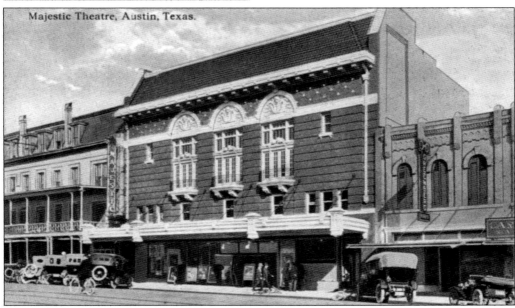

Majestic Theatre, Austin, Texas.

MAJESTIC THEATRE. The Majestic (1915) was located on the east side of Congress Avenue hosting silent pictures, vaudeville acts, and traveling shows. Earnest Nalle built the theater at a cost of $150,000. It was renovated in 1930, at which time a new owner renamed the theater the Paramount. The Paramount has undergone further renovations and is still in operation today. (Published by Abe Frank, Austin; Austin History Center, Austin Public Library.)

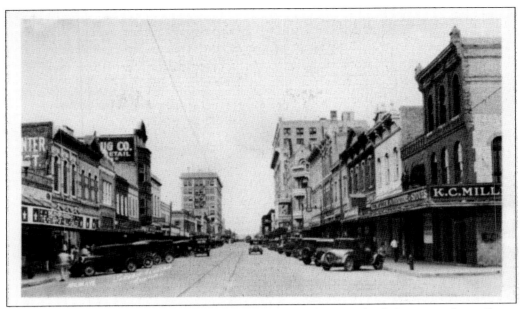

VIEW DOWN SIXTH STREET, FACING WEST. This photograph, facing west down Pecan (Sixth) Street from the corner of Trinity Street, shows K. C. Miller Furniture and Stoves on the right. Unlike today, all the downtown streets were open to two-way traffic. Sixth Street was a popular retail destination because of its relative proximity to the railroad stations and the center of the business district. (Photograph by Jordan Ellison; publisher unknown.)

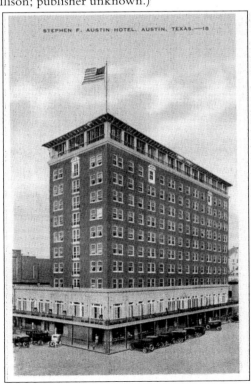

STEPHEN F. AUSTIN HOTEL, POSTMARKED 1924. The Stephen F. Austin Hotel (originally the Texas Hotel) was the city's first high-rise hotel. The original 11 stories built in 1922 were later enlarged with five additional floors. Austin civic leader Walter E. Long arranged for a sale of bonds to construct the hotel, located at Bois D'Arc (Seventh) Street and Congress Avenue. The hotel also served as the convention center for Austin. (Published by E. C. Kropp Company, Milwaukee.)

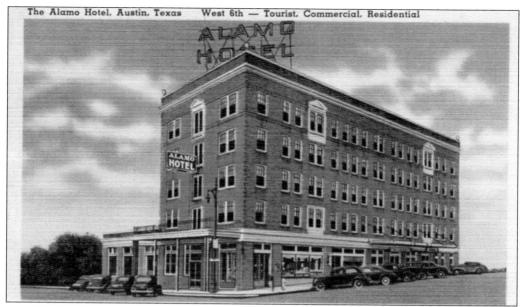

ALAMO HOTEL. The five-story Alamo Hotel was located on West Pecan (Sixth) and Nueces Streets and offered "rooms for short-term visits or long-term residential leases." The hotel had 80 rooms in the "fireproof" building and room rates starting at $2.50. A breakfast of "Brains and Eggs" sold for 40¢, according to *Austin, Texas Then and Now.* An extended stay hotel was built on the site in 2005. (Published by Tichnor Bros., Inc., Boston.)

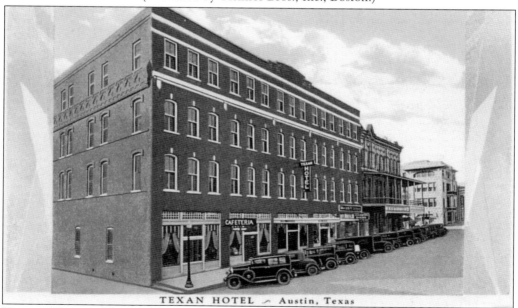

TEXAN HOTEL ⁓ Austin, Texas

TEXAN HOTEL. The Texan Hotel stood at 121 West Bois D'Arc (Seventh) Street with 68 rooms and was later renovated to add air-conditioning. The hotel's slogan was "A friendly place in a friendly city." For many years, Lyndon Johnson's brother, Sam Houston Johnson, lived on the top floor. The Texan was later razed to make way for Capitol National Bank. (Publisher unknown.)

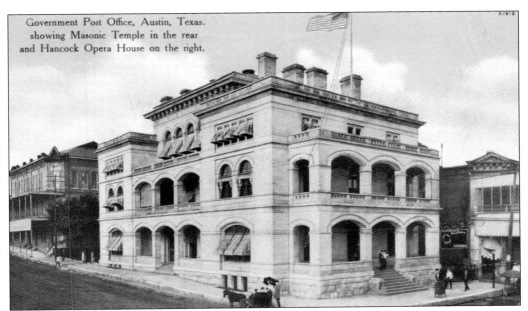

Government Post Office, Austin, Texas. showing Masonic Temple in the rear and Hancock Opera House on the right.

FEDERAL COURTS, POSTMARKED 1913. The post office on Colorado Street also served as the federal courthouse for a time. The building, still in use today, is now an administration building for the University of Texas. UT renamed the building O. Henry Hall because among the trials held in its courtrooms was the embezzlement trial of William Sydney Porter, known by his pseudonym as author O. Henry. (Published by Abe Frank, Austin.)

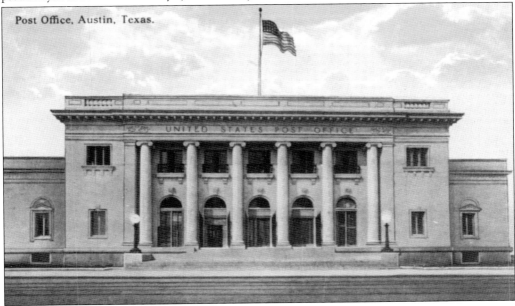

Post Office, Austin, Texas.

UNITED STATES POST OFFICE

POST OFFICE, POSTMARKED 1913. Located at 601 Colorado Street, this building was Austin's first permanent U.S. Post Office. Completed in 1880, it took a decade to build and cost $200,000. Today the building houses the administrative offices of the University of Texas System and has been renamed Claudia Taylor Johnson Hall for Mrs. Lyndon B. Johnson (a University of Texas graduate and former first lady). (Published by Abe Frank, Austin.)

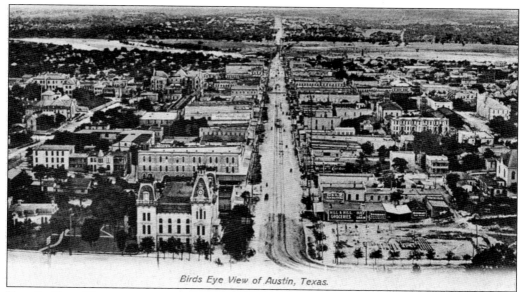

Birds Eye View of Austin, Texas.

BIRD'S-EYE VIEW OF CONGRESS AVENUE (UNDIVIDED BACK). This very-early-1900s view from the capitol dome looks south down Congress and shows the original three-story county courthouse at Mesquite (Eleventh) Street and Congress. The empty lot to the right, across Congress, was the site of the temporary frame-built Capitol Building, used while the permanent granite building was under construction. (Published by S. Langsdorf and Company, New York.)

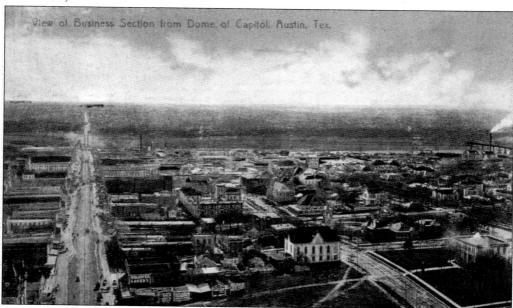

View of Business Section from Dome of Capitol, Austin, Tex.

BIRD'S-EYE VIEW SOUTHWEST, POSTMARKED 1903. Another view from approximately the same time period looks toward the southwest. On the far lower right is the Governor's Mansion, and across Colorado Street is the First Baptist Church. The smoke plume in the distance is probably a cotton compress located adjacent to the railroad tracks and railroad bridge. (Published by St. Louis News Company, St. Louis; Waneen Spirduso collection.)

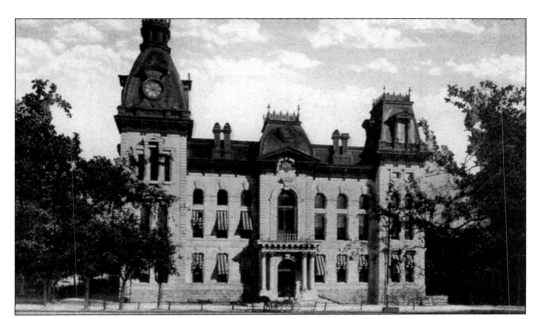

ORIGINAL TRAVIS COUNTY COURTHOUSE. The county courthouse was built in 1876 at the corner of Mesquite (Eleventh) Street and Congress Avenue, just 12 years before the Capitol Building was completed. The courthouse and adjacent jail served until 1930, when the new Travis County Courthouse opened on Guadalupe Street. In June 1918, women were first registered to vote at the original courthouse. (Publisher unknown.)

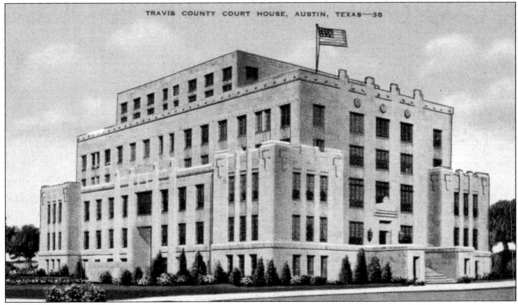

TRAVIS COUNTY COURTHOUSE. The new Travis County Courthouse, still in use today, was built in 1930 to replace the first courthouse at Congress Avenue and Mesquite (Eleventh) Street. The county jail occupied the top two floors of the seven-story building. The building was constructed using fossilized and Cordova cream limestone from a quarry 2 miles from Austin on Manor Road. (Published by E. C. Kropp Company, Milwaukee.)

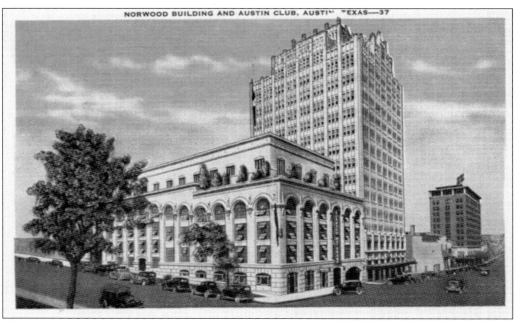

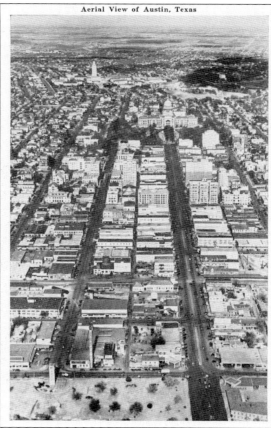

Aerial View of Austin, Texas

NORWOOD TOWER. The 14-floor Norwood Tower with its art deco look was opened in 1929, eclipsing all other Austin office buildings in height. The building owners boasted air-conditioning (a first for an Austin office building) and a "Motoramp," a self-parking ramped automobile garage, another first for Austin. The prestigious Austin Club was located on the fifth floor. (Published by E. C. Kropp Company, Milwaukee.)

AERIAL LOOKING NORTH. This view includes essentially the entire area of downtown Austin as originally platted by Judge Edwin Waller. The Littlefield and Scarborough Buildings (1910–1911) can be seen where Pecan (Sixth) Street crosses Congress Avenue, with the Norwood Tower (1929) off to the left. Past the capitol can be seen the new tower of the University of Texas at Austin. (Published by Caycraft Card Company, Danville, Virginia; Austin History Center, Austin Public Library.)

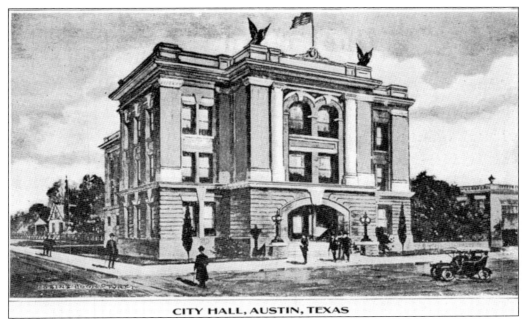

CITY HALL, AUSTIN, TEXAS

CITY HALL. In 1856, Congress granted the land formerly occupied by the first Capitol Building, at the corner of West Hickory (Eighth) and Colorado Streets, to the City of Austin for a city hall. The first city hall was built here in 1870. This newer three-story building was erected in 1907. In 1938, the building was extensively remodeled and enlarged. (Published by City Post Card Company, Austin.)

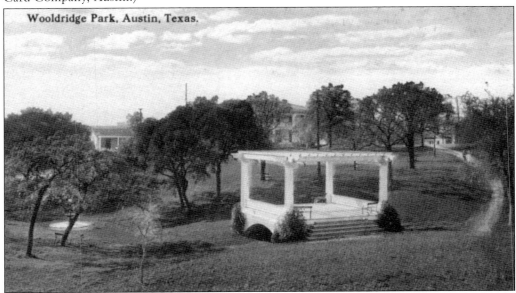

Wooldridge Park, Austin, Texas.

WOOLDRIDGE PARK. Although the block was always planned by Edwin Waller to be a park (one of four parks in the original city plan), it was not until June 1909 that it became one including a park pavilion and quickly became a favored gathering place. It was named for Alexander Wooldridge, a civic leader, University of Texas regent, and mayor. (Published by Abe Frank, Austin; Austin History Center, Austin Public Library.)

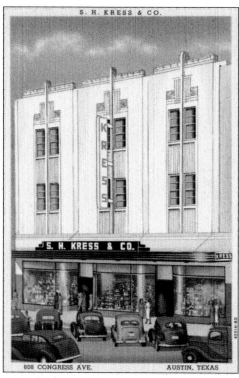

S. H. KRESS AND COMPANY. Located at 808 Congress Avenue (on the west side), S. H. Kress was an immensely popular department store, especially known for its variety of women's shoes. This is an excellent example of the popular stylized "Colortone" postcards produced in vast numbers by the Curt Teich Company of Chicago between 1930 and 1945. Airbrushing adds a stylized look to the image. Today these are highly collectible. (Published by Curteich-Chicago, "C. T. Art Colortone.")

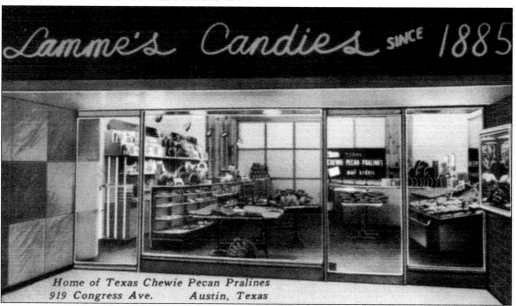

LAMME'S CANDIES. "Home of the Texas Chewie Pecan Pralines," Lamme's Candy, opened on Congress Avenue in 1885, is an Austin institution as popular now as it was back then. Today their popular chewy pecan clusters are sent by Austinites to friends around the country. The location at 919 Congress Avenue continued in operation from 1885 until the 1990s. Today, however, the location is a Starbucks. (Published by Advance Advertising, Houston.)

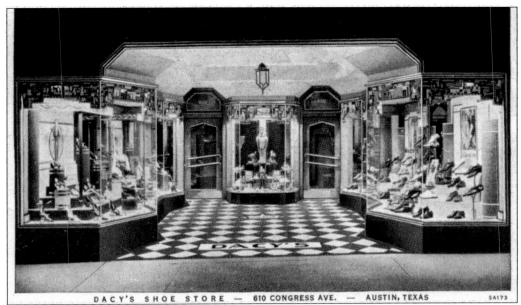

DACY'S SHOE STORE — 610 CONGRESS AVE. — AUSTIN, TEXAS 5A173

DACY'S SHOES. Located at 610 Congress Avenue, Dacy's was a popular store carrying all the national brands of shoes. Kids loved to go into the store to look at their feet through the X-ray machine. The X-ray was intended to help patrons ensure that the shoes fit their feet correctly. "We fit by X-ray" is the sales slogan on the reverse. (Published by Curt Teich and Company, Chicago; Waneen Spirduso collection.)

CARL MAYER COMPANY, JEWELERS. Located at 618 Congress Avenue, Carl Mayer ("Silversmiths and Diamond Dealers. Established 1864") advertised in the University of Texas yearbooks beginning in approximately 1920 with the slogan "We welcome you to the City of the Violet Crown." The term "violet crown" describes the deep purplish color of the sky and hills as the sun sets over the Austin hills, usually on clear winter evenings. (Publisher unknown; Waneen Spirduso collection.)

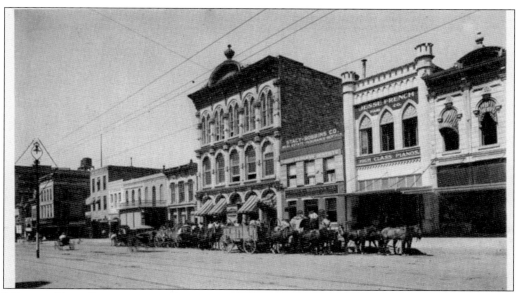

WALTER TIPS BUILDING. On the east side of Congress Avenue between Hickory (Eighth) and Ash (Ninth) Streets is the Walter Tips Company hardware building. The three-story structure was designed in 1876 by Jasper Preston, the first architect to move to Austin. He also designed the Driskill Hotel. The interior columns and girders were crafted from recast Confederate artillery shells. A mule-drawn wagon team is seen loading supplies in this undivided-back card. (Publisher unknown.)

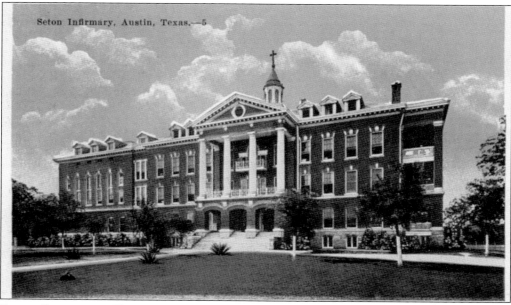

SETON INFIRMARY, POSTMARKED 1915. Founded by the Daughters of Charity of St. Vincent de Paul, Seton opened its doors in 1922 at a site located at Twenty-sixth and Nueces Streets. Locals raised funds for the land for the facility. It was later demolished and reopened on Thirty-fifth Street, its present location. The hospital is named for Elizabeth Ann Seton, founder of the Daughters of Charity. (Published by E. C. Kropp Company, Milwaukee.)

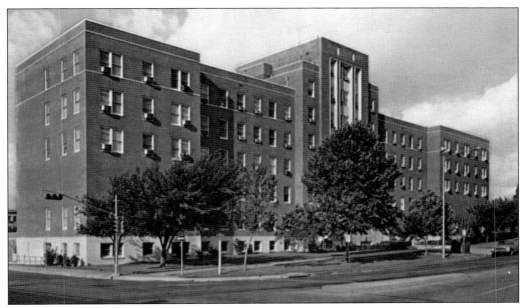

BRACKENRIDGE HOSPITAL (MODERN CHROME). Originally called the City-County Hospital, this facility was built in 1915 as an addition to the original hospital of 1884. Located at North (Fifteenth) Street and East Avenue, it has since expanded considerably. In 1929, the hospital was named after Dr. Robert Brackenridge, who played a key role in convincing the city of the need for a modern hospital. (Published by Gough Photo Service, Houston.)

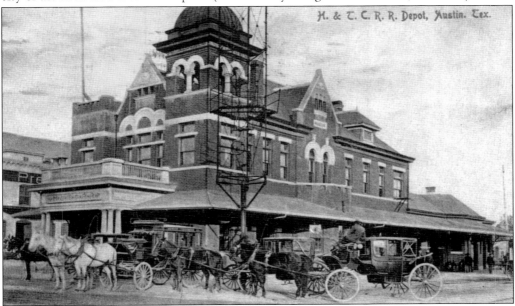

HOUSTON AND TEXAS CENTRAL RAILROAD. The first railroad to arrive in Austin (the H&TC) pulled into town on Christmas Day 1871. With the train, it suddenly became possible to go from Austin to Houston in just one day. The railroad vastly lowered shipping costs and opened up markets for crops such as cotton, making Austin a trading center for the surrounding area. (Published by Sauter and Kuehne, Austin; Austin History Center, Austin Public Library.)

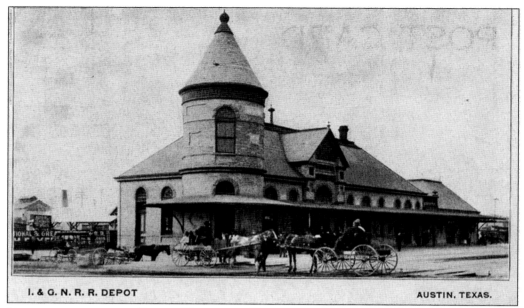

I. & G. N. R. R. DEPOT AUSTIN, TEXAS.

INTERNATIONAL AND GREAT NORTHERN RAILROAD (UNDIVIDED BACK). The second of Austin's railroads was the International and Great Northern Railroad (I&GNRR). It arrived in Austin from Palestine on December 28, 1876, and operated from a busy depot on Cypress (Third) Street. By this time, other railroads were beginning to crisscross the region, taking away Austin's sole dominance as a trade center. (Publisher unknown.)

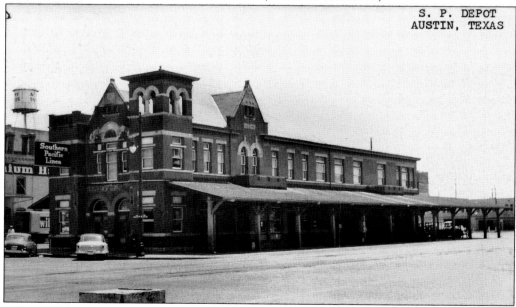

S. P. DEPOT
AUSTIN, TEXAS

MK&T DEPOT (RPPC). The Missouri, Kansas, and Texas depot was located at the southwest corner of Cypress (Third) Street and Congress Avenue. On the MK&T line, passengers could ride to Missouri, St. Louis, Chicago, and other cities. Here a horse and buggy as well as two stagecoaches arrive at the depot. Note, too, the base of a moon tower in the foreground. (Published by Sauter and Kuhne, Austin; Waneen Spirduso collection.)

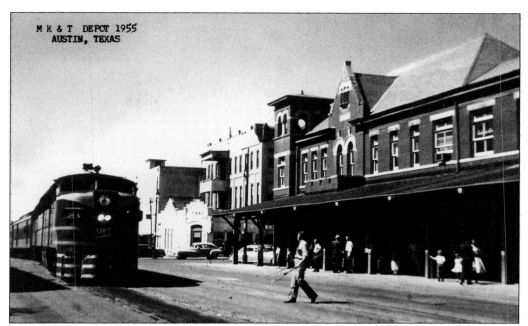

MK&T RAILROAD. In the 1940s and 1950s, the train still ran through downtown Austin and across Congress Avenue along Third Street. The train depot from the earlier postcard has changed somewhat but is still recognizable. By now, trains used diesel power instead of coal. This site is now a downtown parking lot. (Publisher unknown; Waneen Spirduso collection.)

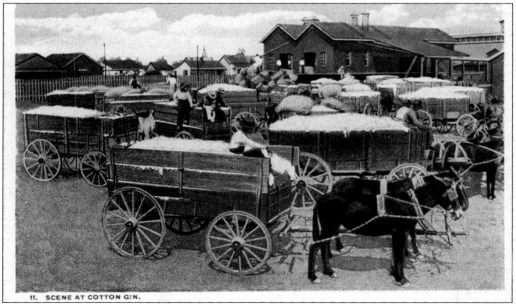

11. SCENE AT COTTON GIN.

COTTON! The largest agricultural export from Central Texas was cotton. Raw cotton from the fields was transported by wagon to a gin, where the cotton was processed to remove the seeds and compressed into bales suitable for transport by railroad to ports such as Houston and Galveston. Space–saving compressed bales were necessary because state law prohibited raw cotton from transport by rail past a working cotton gin. (Published by C. T. American Art.)

29

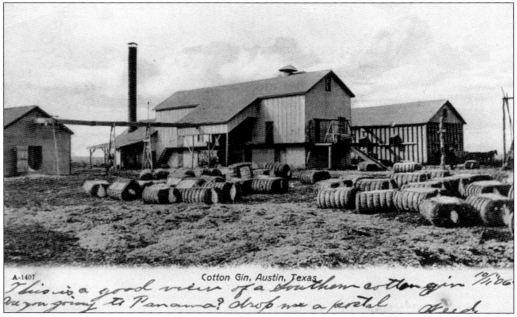

A-1407 Cotton Gin, Austin, Texas 10/1/06

This is a good view of a Southern cotton gin. Are you going to Panama? drop me a postal

COTTON GIN, POSTMARKED 1906 (UNDIVIDED BACK). Seeds in the handpicked cotton had to be removed before baling, which meant a trip to the gin (short for the "cotton engine" patented by Eli Whitney in 1793). The ginning process automated the operation of separating the seeds from the fiber. The remaining seedless fiber is then baled using a screw compress. (Published by Langdorf and Company, Germany.)

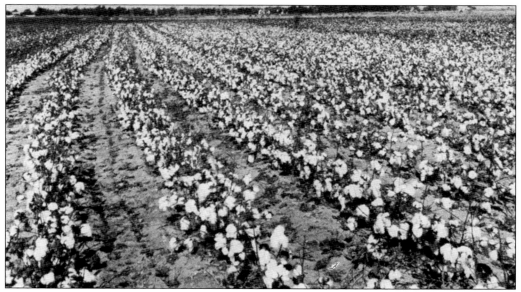

THE COTTON CROP. Cotton was one of the few crops produced locally for export. Austin sits at the fault line between the porous limestone hills to the west and the fertile "blackland" prairie to the east. The deep, rich black soils to the east were perfect for growing cotton. Towns like Taylor and Hutto were major producers and shippers of cotton. (Publisher unknown.)

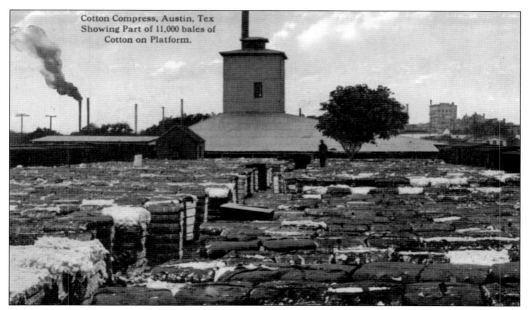

COTTON BALES. This scene shows part of 11,000 bales of cotton on the Austin railroad platform. Also, with Austin being along the Chisholm Trail, drovers pushed cattle north along the trail to the railroad. The coming of railroads opened up the trade for cotton, which was primarily sent to Galveston, and cattle were sent to St. Louis. (Published by Abe Frank, Austin; Waneen Spirduso collection.)

DIRECTING TRAFFIC. Policemen often were called into duty to direct traffic in the growing city, such as here at Pine (Fifth) Street and Congress Avenue. The vertical sign on the right side of Congress in the distance of this modern chrome postcard is the Paramount Theatre (formerly the Majestic Theatre), which has been a Congress Avenue landmark since 1930. (Published by Austin News Agency.)

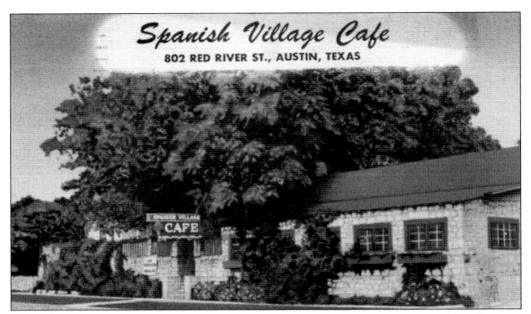

SPANISH VILLAGE CAFE. Several early Austin restaurants survive today because of their location and/or popularity. The Spanish Village Cafe at 802 Red River Street had both location and popularity. The restaurant claims to be "Austin's Original Mexican Restaurant" excelling in "Fine Food and Friendly Service . . . and Air Conditioning." (Published by Frank Polk Advertising Company, Austin.)

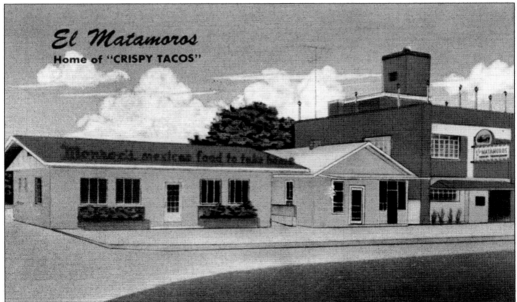

EL MATAMOROS (EL MAT). Another still-famous restaurant is El Matamoros, shown here at 504 East Avenue. (East Avenue later became IH–35). On the reverse, the postcard says, "One of the best Mexican food restaurants in Central Texas, serving Mexican dishes and those famous 'Crispy Tacos,' steaks and fried chicken. One of the best equipped stainless steel kitchens. Established in 1947." (Published by Frank Polk Advertising Company, Austin.)

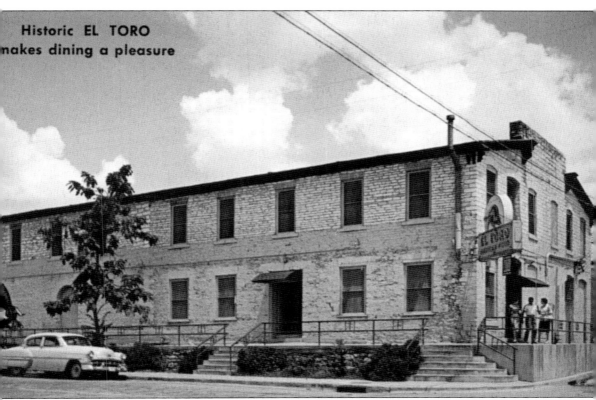

EL TORO. El Toro was known for its famous building, originally built in 1853 as a trading post on the outskirts of Austin. The town eventually grew to surround the building (at Sixteenth and Guadalupe Streets). Its belowground wine cellar originally stored casks of gunpowder, molasses, wine, and whiskey at various times. The restaurant is now the Clay Pit. (Published by Edwin J. Schramel, Austin.)

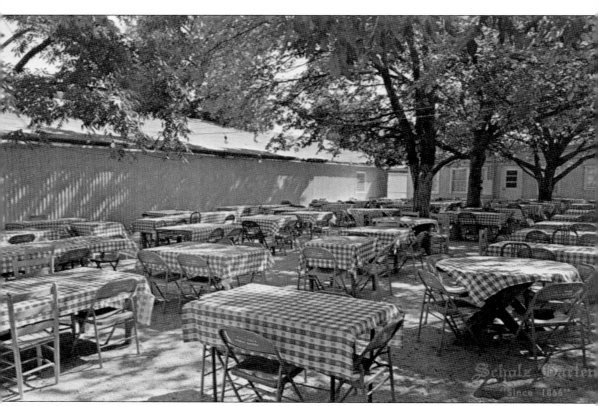

SCHOLZ GARTEN, "SINCE 1866." Austin's oldest restaurant still standing today is Scholz Garten. Built in 1866, it is the oldest continually operating "bier garten" in Texas. The original owner, August Scholz, sold the building in 1908 to the Austin Saengerrunde (a German singing society), who added the Saengerrunde Hall to the main building. Scholz has long been a favorite of politicians and University of Texas students, still serving German food, chicken-fried steak, and cold beer. (Published by Dorph Photography, Austin.)

Two

DOWNTOWN CHURCHES

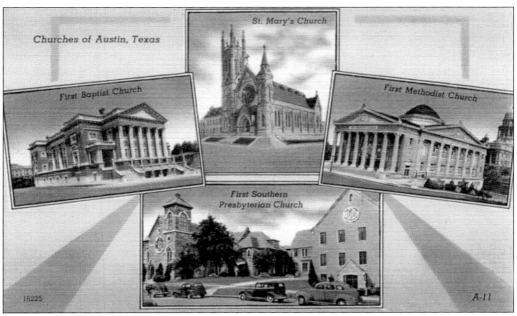

AUSTIN AREA CHURCHES. At least eight major churches were built in the late 1800s in downtown Austin, most within 10 years of each other. Each had its own individual character, ranging from master builder Abner Cook's First Presbyterian Church to the St. Mary's Cathedral designed by the Victorian architect Nicholas Clayton. This postcard highlights four of them. (Published by Colourpicture, Cambridge, Massachusetts; distributed by the Hausler-Kilian Cigar and Candy Company, Austin.)

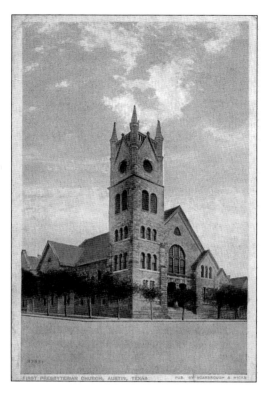

FIRST PRESBYTERIAN CHURCH, AUSTIN, TEXAS. PUB. BY SCARBROUGH & HICKS

FIRST PRESBYTERIAN CHURCH, POSTMARKED 1913. In 1839, Presbyterians organized the first church in Austin, which initially met in the first Capitol Building. Abner Cook, a charter member and master builder, later donated land at Bois D'Arc (Seventh) and Lavaca Streets for the church. The first sanctuary, a frame church, was completed in 1851. It was replaced by this stone structure in 1890. (Published by Scarborough and Hicks, Austin; Waneen Spirduso collection.)

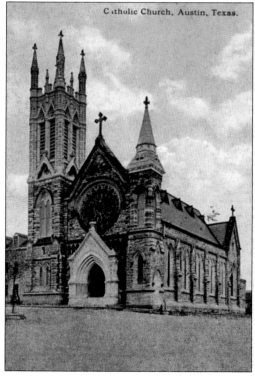

Catholic Church, Austin, Texas.

ST MARY'S CATHEDRAL, POSTMARKED 1915. After designing St. Mary's Cathedral in Galveston, renowned Victorian architect Nicholas Clayton designed a similarly striking church in Austin. St. Mary's is located on a hill at the southeast corner of Mulberry (Tenth) and Brazos Streets. The Austin church was finished in 1874, with additional stained–glass ornamentation added in the 1890s. Clayton also designed St. Edward's University's distinctive Old Main Building. (Publisher unknown.)

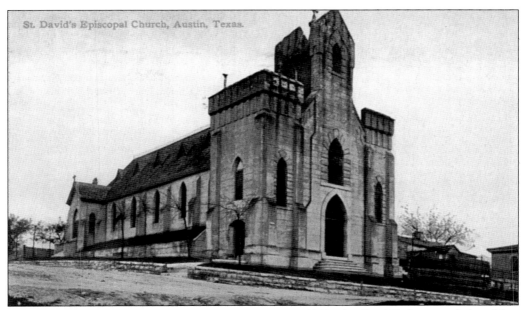

ST. DAVID'S EPISCOPAL CHURCH, POSTMARKED 1910. St. David's is one of the oldest buildings in Austin and one of the oldest Episcopal churches west of the Mississippi. A small limestone structure was built in 1853, which was expanded in 1870 to the current configuration and more elaborate exterior. It sits on top of a hill at 304 East Bois D'Arc (Seventh) Street and has a commanding view of town. (Publisher unknown.)

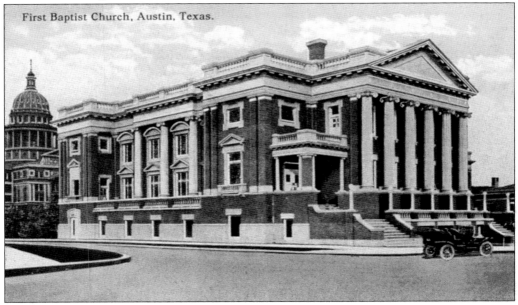

FIRST BAPTIST CHURCH. Between 1847 and 1855, the Baptists met in the state capitol, a one-story building at Hickory (Eighth) and Colorado Streets, and later on the third floor of the Lamar-Moore Building at 700 Congress Avenue. The church building, seen here, is a few blocks southeast of the permanent state capitol building. Some of the most prominent families in the city worshipped here. (Published by Abe Frank, Austin; C. T. Photochrom.)

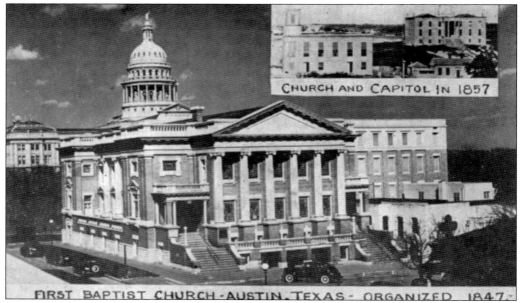

CHURCH AND CAPITOL IN 1857

FIRST BAPTIST CHURCH · AUSTIN, TEXAS · ORGANIZED 1847·

FIRST BAPTIST CHURCH. This older undivided-back postcard for the First Baptist Church is unusual in that it shows how the church and the older state capitol looked together. It shows the second state capitol—the capitol building that burned before the current permanent capitol was constructed. The church was located across Colorado Street from the Governor's Mansion. (Publisher unknown; Austin History Center, Austin Public Library.)

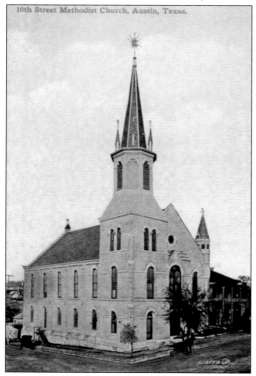

10th Street Methodist Church, Austin, Texas.

FIRST METHODIST CHURCH. Founded in 1847, the Austin Methodist congregation worshipped in a small red-brick church at Brazos and Mulberry (Tenth) Streets until 1883, when, under the leadership of Rev. A. E. Goodwyn, it was razed and replaced by this steepled structure. The church was referred to as Tenth Street Church until 1902, when it was officially renamed the First Methodist Church. (Published by Valentine and Sons Publishing Company, New York and Boston.)

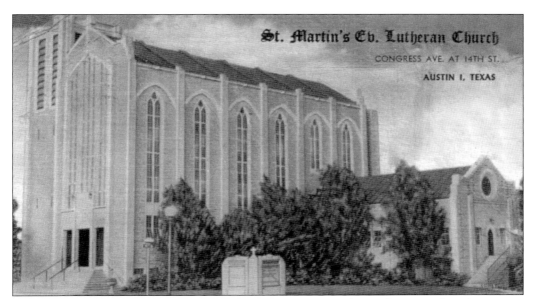

ST. MARTIN'S EVANGELICAL LUTHERAN CHURCH. The Lutherans have worshiped in Austin for some 125 years. Their first building, on Peach (Thirteenth) Street, was purchased by the state as part of the 22 acres needed for the capitol grounds. This white stone Gothic structure on Walnut (Fourteenth) Street was dedicated in 1929. It, too, was later purchased by the state and demolished. The church is now located at 606 West Fifteenth Street. (Published by MWM Color Litho, Aurora, Missouri.)

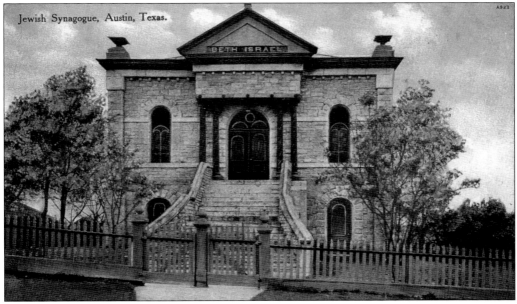

BETH ISRAEL JEWISH SYNAGOGUE. This was home to Austin's oldest and largest Jewish congregation. In September 1876, a group of pioneer Jews organized Congregation Beth Israel. Chartered by the state in 1879, the first synagogue was built in 1884 on the corner of Mesquite (Eleventh) and San Jacinto Streets. The church has since been relocated to 3901 Shoal Creek Boulevard. (Published by Tobin's Book Store, Austin; Waneen Spirduso collection.)

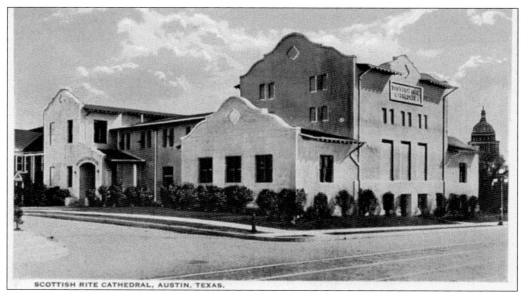

SCOTTISH RITE CATHEDRAL, AUSTIN, TEXAS.

SCOTTISH RITE CATHEDRAL. Ancient Free and Accepted Masonry was first introduced to Austin in October 1839, with the creation of Lodge 12, which moved from meeting place to place until the construction of the Austin Scottish Rite Building in 1923 at Eighteenth and Lavaca Streets. Numerous Austin buildings had their cornerstones laid and leveled by Lodge 12, including many churches and the state capitol building. (Published by Abe Frank, Austin; C. T. Photochrom.)

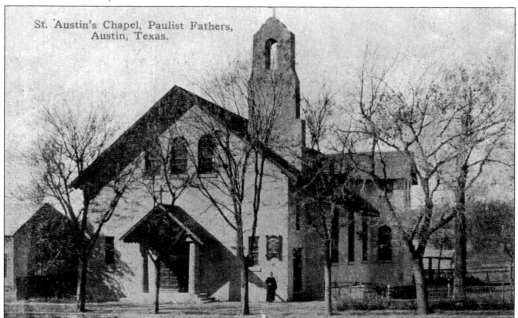

St. Austin's Chapel, Paulist Fathers, Austin, Texas.

ST. AUSTIN'S CHAPEL, PAULIST FATHERS. Located at the southwest corner of Guadalupe and Twenty-first Streets, the church today is known as the St. Austin Catholic Church. Founded in 1908, the church celebrated its 100th anniversary in 2008. (Published by E. C. Kropp Company, Milwaukee; Waneen Spirduso collection.)

Three

STATE CAPITOL AND STATE OFFICES

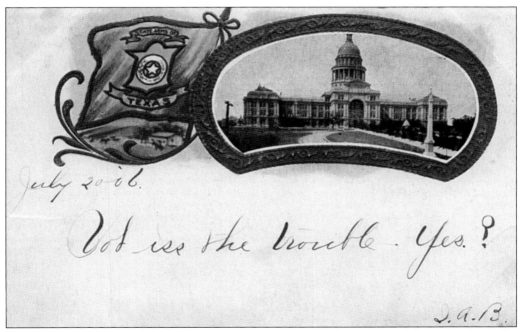

TEXAS STATE CAPITOL BUILDING. This Private Mailing Card, postmarked 1906, shows the permanent Capitol Building and the "State Arms of Texas." The border around the view of the capitol is embossed, indicating that the card was likely printed in Germany. Private Mailing Cards—the first postcards—were authorized May 19, 1893, and were only made until 1901. This card was not mailed, however, until July 1906. (Publisher unknown.)

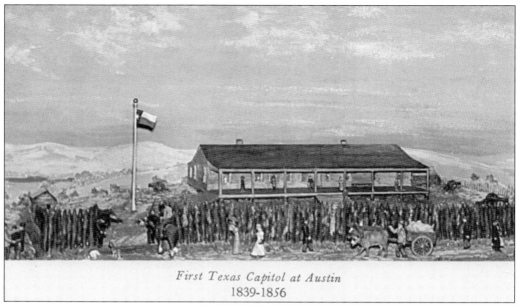

First Texas Capitol at Austin
1839-1856

FIRST CAPITOL OF TEXAS. A diorama from the San Jacinto Museum depicts the first Capitol Building, a log structure located at Hickory (Eighth) and Colorado Streets. It was built in 1839, where Austin's first city hall was later constructed. Because of Native American raids, the capitol was constructed like a fortress with a stockade of cedar posts in case of attack. The building burned in 1853. (Published by American Post Card Company, Houston.)

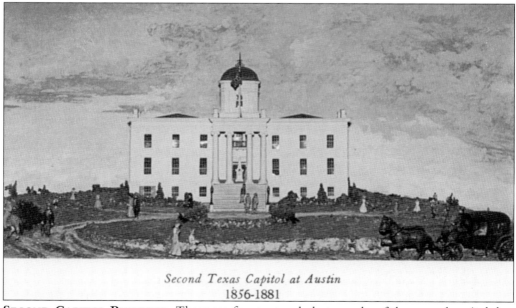

Second Texas Capitol at Austin
1856-1881

SECOND CAPITOL BUILDING. There are few postcard photographs of the second capitol, but fortunately there is a postcard of the diorama model of it in the San Jacinto Museum. The second capitol was constructed of stone, in 1853, after the first capitol burned. It, too, was gutted by fire, in 1881. It was located on the same spot where today's Capitol Building sits. (Published by American Post Card Company, Houston.)

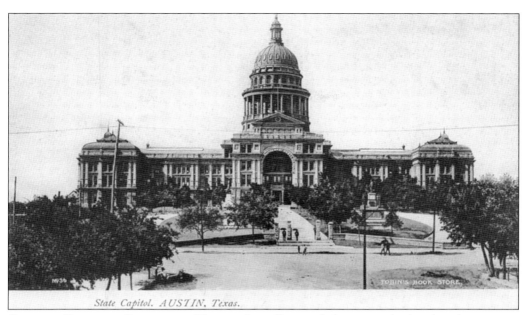

State Capitol. AUSTIN, Texas.

CAPITOL BUILDING LOCATION. The previous diorama helps to emphasize that the present-day Capitol Building sits on a hill, as can be seen in this postcard postmarked 1908. While the capitol was being built, a temporary third structure was erected (to the left of this image). The legislature, and even some University of Texas classes, met there until the new permanent building was completed in 1888. (Published by St. Louis–Leipzig; printed in Germany.)

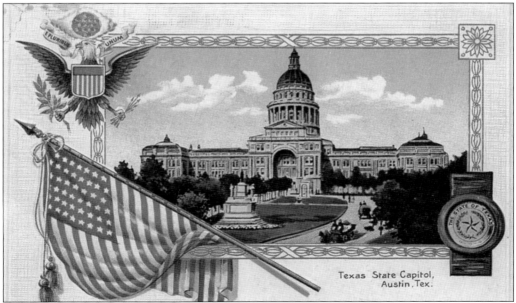

Texas State Capitol, Austin, Tex.

TEXAS CAPITOL WITH U.S. FLAG. It is likely that more postcards have been produced of the State Capitol Building than of any other Austin subject. Most Austin postcard collectors own numerous views. This one shows an embossed state seal and embossed U.S. flag and eagle. The texture and embossing is indicative of a card made by the master German engravers. (Published by Langsdorf and Company, New York; made in Germany.)

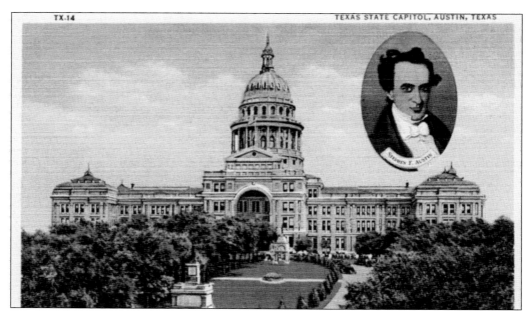

TEXAS STATE CAPITOL WITH STEPHEN F. AUSTIN. Stephen F. Austin, the father of the Texas, was one of the "empresarios," or colony chiefs, under the Mexican regime to bring immigrants to Texas from the United States. He brought the first group of settlers, known as The Old Three Hundred. Later he became a leader in the effort for Texas independence from Mexico. (Published by Curteich, Chicago. "C. T. Art–Colortone.")

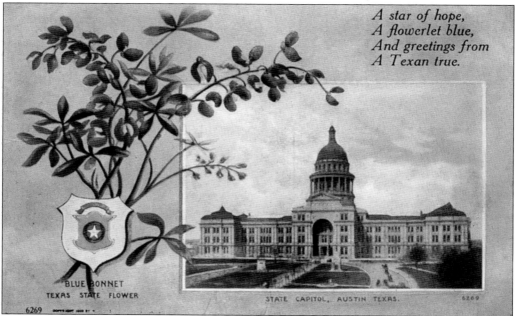

BLUEBONNET WITH CAPITOL BUILDING. This card shows the Capitol Building as an inset image with the Texas state flower, the bluebonnet. Also a "lone star" crest and a few lines of poetry from an unknown poet are included. The capitol was completed in 1888 at a cost of $3,744,630.60. It was designated a historic landmark in 1986. (Publisher unknown.)

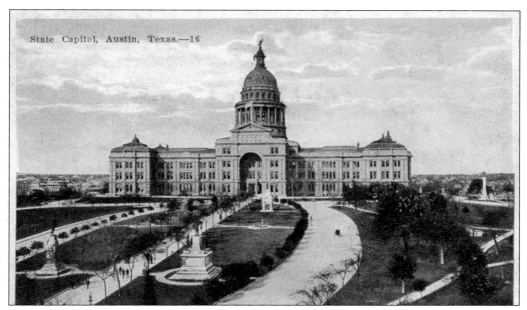

State Capitol, Austin, Texas.—16

CAPITOL GROUNDS, POSTMARKED 1914. As the capitol was being finished, the legislature passed legislation to hire a civil engineer, William Munro Johnson, to design and improve the 22 acres of surrounding grounds. Johnson devised a plan with two wide, curving driveways for carriages (shown here), a "Great Walk" of black and white diamond-patterned pavement, and the location of the first major monuments. (Published by E. C. Kropp Company, Milwaukee.)

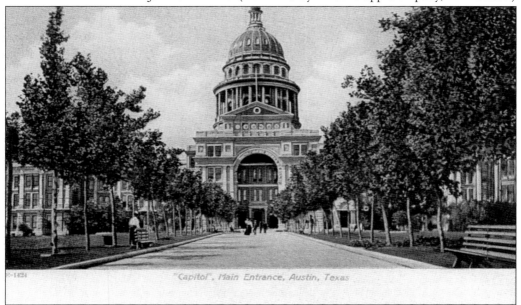

"Capitol", Main Entrance, Austin, Texas

PLANTED TREES (UNDIVIDED BACK). The original trees along the Great Walk were American elms, but they succumbed to Dutch elm disease. Since little was then known about the disease, elms were planted again in 1920. They subsequently died and were replaced by live oaks. When the capitol grounds were restored in 1996, the beyond-their-prime oaks were removed and new ones planted. (Published by S. Langdorf and Company, New York; printed in Germany.)

45

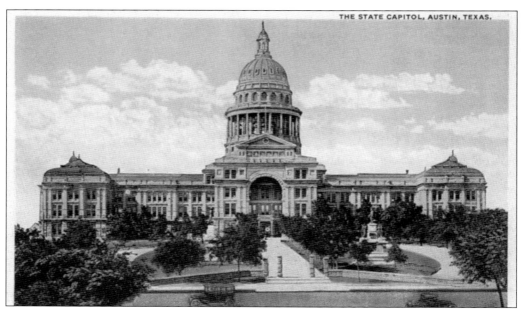

STATE CAPITOL (WHITE-BORDER CARD). Originally the building was to be made of limestone, but the stone that was quarried raised concerns about discoloring and weathering. Granite was then chosen. The owners of Granite Mountain in Marble Falls donated the "Sunset Red" granite and 1,000 laborers to the project. A new railroad line between Austin and Burnet was used to move the stone to the capitol. (Publisher unknown.)

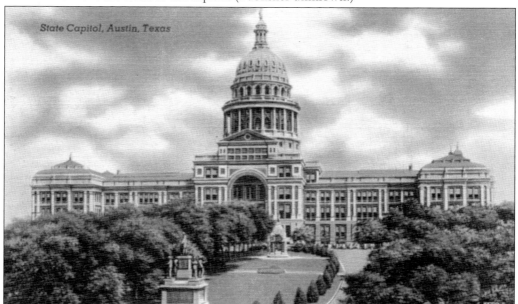

State Capitol, Austin, Texas

STATE CAPITOL, AUSTIN, TEXAS. The use of granite resulted in a stunning building. At 308 feet tall, it was the seventh tallest building in the United States when completed in 1888. As compensation for building the capitol, the state gave the contractor three million acres of land in West Texas (valued at 50¢ per acre). Much of that land now makes up the famous XIT ranch. (Publisher unknown.)

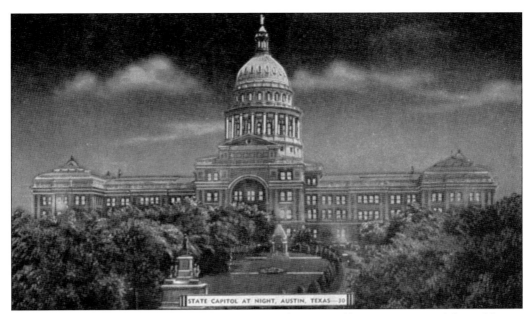

THE CAPITOL AT NIGHT. Illuminated, the capitol is especially impressive at night and is one of the first things noticed by visitors approaching Austin from any direction. The dome was originally designed to be brick, but because of the excessive weight, it was redesigned using iron braces. The "Goddess of Liberty," standing nearly 16 feet tall, provided the finishing touch at the top of the dome. (Published by E. C. Kropp Company, Milwaukee.)

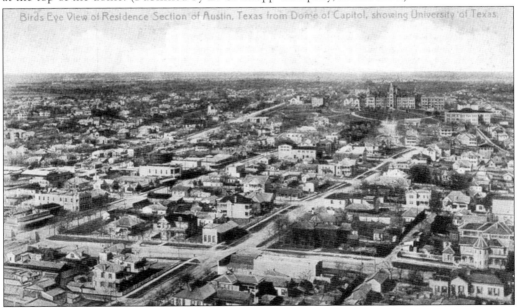

BIRD'S-EYE VIEW OF THE RESIDENCE SECTION OF AUSTIN. This view from the top of the dome of the capitol provides a look to the north. The Old Main building at the University of Texas can be seen prominently in the distance. Today much of this area is filled with state office buildings, parking garages, and museums. (Published by the St. Louis News Company, St. Louis.)

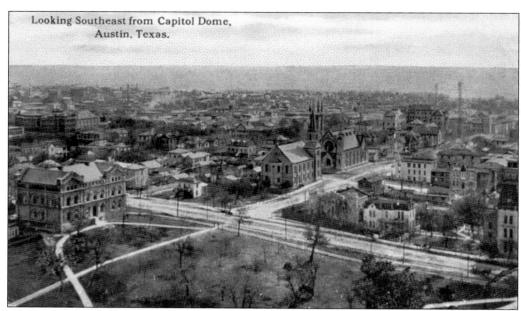

Looking Southeast from Capitol Dome,
Austin, Texas.

BIRD'S-EYE VIEW SOUTHEAST FROM THE CAPITOL DOME, POSTMARKED 1913. The building located on the capitol grounds is the Old Land Office, the oldest state building in Austin (1857). The steepled First Methodist Church and St. Mary's Cathedral can be seen on the north and south side of Mulberry (Tenth) and Brazos Streets. At the bottom right corner is a portion of the original Travis County Courthouse. (Published by S. H. Kress and Company.)

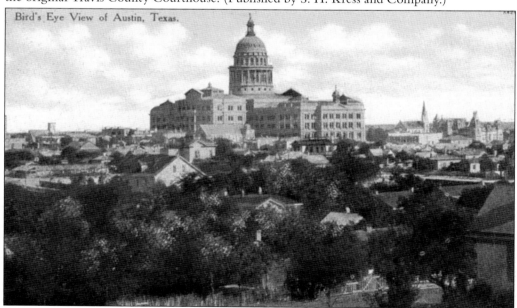

Bird's Eye View of Austin, Texas.

BIRD'S-EYE VIEW OF AUSTIN, TEXAS. It is difficult to determine exactly from where this northwestern view was taken, but the capitol is certainly an imposing structure for its time. The City of Austin and the state legislature (in 1983 and 1985 respectively) enacted a number of protected Capitol View Corridors so that new, taller buildings would not obstruct primary views of the capitol. (Publisher unknown.)

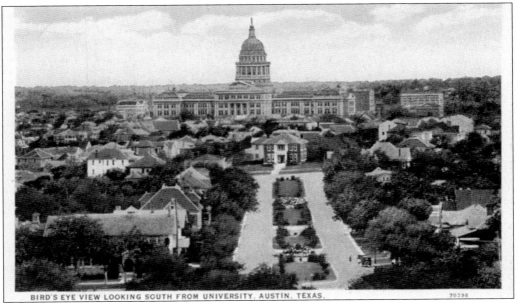

BIRD'S EYE VIEW LOOKING SOUTH FROM UNIVERSITY, AUSTIN, TEXAS.

BIRD'S-EYE VIEW OF AUSTIN. This view, from the north-northwest, is looking down University Boulevard from the Main Building at the University of Texas. The house at the end of the street is on Nineteenth Street but no longer exists today. University Drive provides a primary view into campus looking down University Drive to the Littlefield fountain and the UT Tower beyond. (Published by Abe Frank Cigar Company, Austin.)

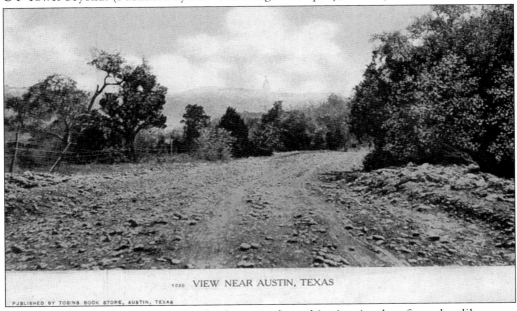

VIEW NEAR AUSTIN, TEXAS

PUBLISHED BY TOBINS BOOK STORE, AUSTIN, TEXAS

VIEW NEAR AUSTIN, TEXAS. It is hard to say where this view is taken from, but like many Austin images of its time, it has the capitol dome in the background. Before the 1920s, few roads had been paved (the paving of downtown began in 1905). Even then, most outlying roads were still dirt roads. This road certainly had its share of rocks. (Published by C. T. Company, Chicago, and Tobin's Book Store, Austin.)

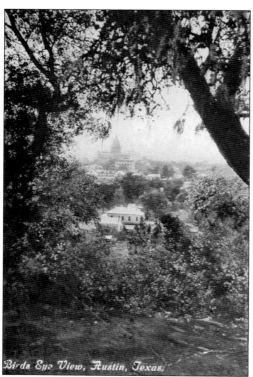

WESTERN BIRD'S-EYE VIEW, AUSTIN, TEXAS. Looking toward the capitol, this view is from the hills west of present-day Lamar Boulevard. Hundreds of Austin images include the iconic capitol in some manner. The message on the back says the writer is leaving tomorrow to attend the Texas v. A&M football game. (Published by Abe Frank, Austin.)

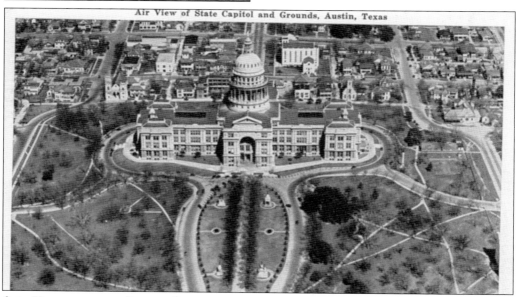

AIR VIEW OF THE STATE CAPITOL AND GROUNDS. This view (a white-border card typically dating between 1915 and 1930 but postmarked 1941) provides an overview of the capitol grounds. The four primary monuments along the south walkway (out of a total of 17 monuments overall) are *Heroes of the Alamo*, *Confederate Soldiers*, *Volunteer Firemen*, and *Terry's Texas Rangers*. (Photograph by Southwestern Aerial Survey; published by Graycraft Card Company, Danville, Virginia.)

CONFEDERATE SOLDIERS MONUMENT, POSTMARKED 1907 (UNDIVIDED BACK).
Erected in 1903 by surviving members of the Confederate army, the statue depicts figures representing the cavalry, infantry, artillery, and navy topped by Jefferson Davis. It also provides detail about the Civil War "waged for states rights guaranteed under the Constitution." Pompeo Coppini (1870–1957) was the sculptor of the bronze statutes that are mounted on a gray granite base. (Published by Langdorf and Company, New York and Germany.)

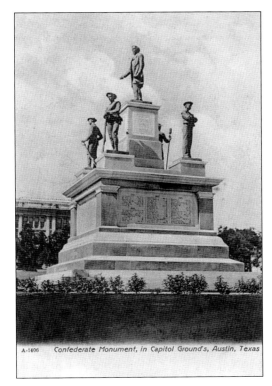

A-1406 Confederate Monument, in Capitol Ground's, Austin, Texas

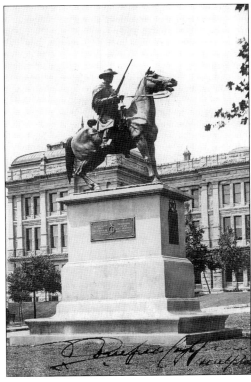

TERRY'S TEXAS RANGERS. The bronze statue portrays one of Terry's Texas Rangers on horseback. In 1861, Terry's Texas Rangers were formed when Benjamin Terry and Thomas Lubbock called for volunteers. Ten companies of 100 men each were formed and participated in the Civil War on the side of the Confederacy. Pompeo Coppini created this sculpture, erected in 1907, and this postcard appears to be personally signed by him. (Publisher unknown.)

51

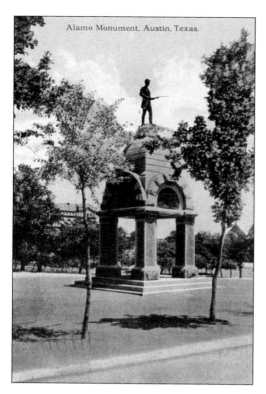

Alamo Monument, Austin, Texas.

ALAMO MONUMENT, POSTMARKED 1912.
This monument by J. S. Clark was erected
in 1891 and depicts a defender of the Alamo
holding his muzzle-loader rifle. In 1836,
some 187 "Texians," under the command of
Col. William B. Travis, defended the Alamo
mission for 13 days against an estimated
5,000 troops led by Mexican general Santa
Anna. All of the Texians died in the battle.
(Published by Sauter and Kuehne, Austin.)

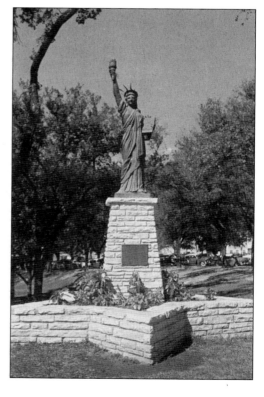

REPLICA *STATUE OF LIBERTY*. This
bronze replica of the *Statue of Liberty* was
erected in 1951 by the Boy Scouts of Texas
near the main entrance to the capitol.
In 1996, it was relocated to the north
side of the capitol and placed on a new
pedestal. A time capsule, buried nearby,
is to be opened by Scout officials in 2076.
(Published by Dan R. Bartels, McAllen.)

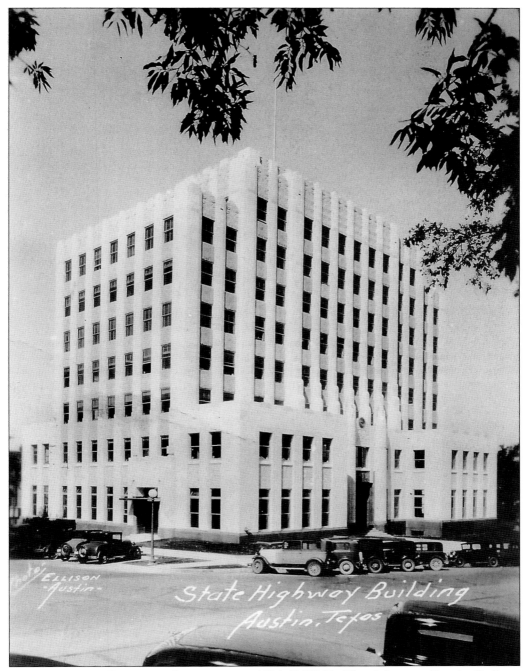

STATE HIGHWAY BUILDING, POSTMARKED 1934 (RPPC). The eight-story Dewitt C. Greer State Highway Building was finished in 1933 at a cost of $455,000. It is located at the northwest corner of Mulberry (Eleventh) and Brazos Streets. The building was designed by San Antonio architect Carleton Adams and features elaborate art deco styling, including decorative carved limestone panels above the front doors. It was added to the National Register of Historic Places in 1998. (Ellison Photograph; publisher unknown.)

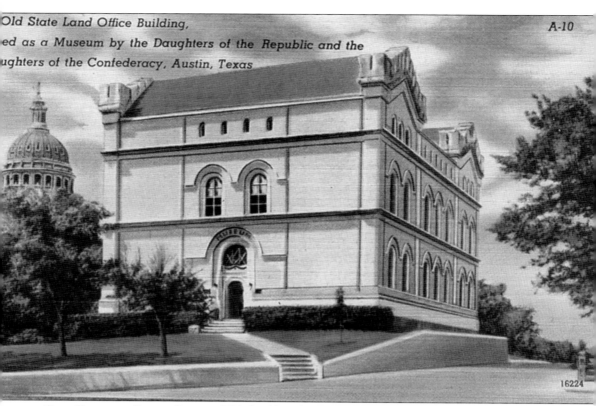

16224

OLD GENERAL LAND OFFICE. This building has been painstakingly restored and now serves as the Capitol Visitors Center. Built in 1856–1857, it is the oldest state office building in Austin. During the years of the Republic of Texas, the building and its built-in safes housed the state archives and the original land title information all the way back to the Mexican land grants. A skirmish called the Archive War happened between Sam Houston's men and the citizens of Austin in 1842–1843. When the Mexican army invaded San Antonio, Texas president Sam Houston saw his chance to move the capital from Austin (which he called "the most unfortunate site on earth for a seat of government") to his namesake town—Houston. The citizens of Austin warned that anyone who attempted to move the state papers would be met with "armed resistance" and formed a "Committee of Safety." In December 1842, rangers sent by Sam Houston were able to sneak into town and seize the papers after the committee found themselves unprepared for the raid. Angelina Eberly did get to fire off a cannon shot at the rangers, but to no avail. On January 1, 1843, the Austin committee overtook the rangers who were camped at Brushy Creek in Williamson County. The rangers were forced to surrender to avoid bloodshed, and the papers were returned to Austin. (Published by Hausler-Kilian Cigar and Candy Company, Austin.)

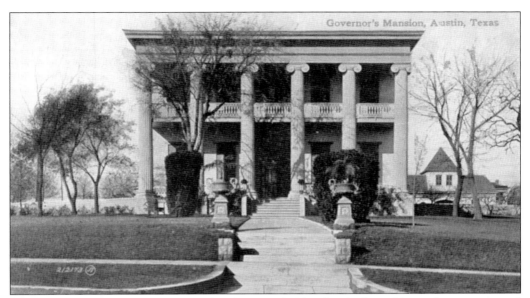

EARLY GOVERNOR'S MANSION. The Governor's Mansion is the subject of many postcard views. Architect Abner Cook, designer of several Greek revival homes in Austin, won the contract to design the Governor's Mansion when his $15,000 bid was the lowest one. The building has been the official residence of every Texas governor since Gov. Elisha Marshall Pease moved into the nearly completed mansion on June 15, 1856. (Published by Leighton and Valentine Company, New York.)

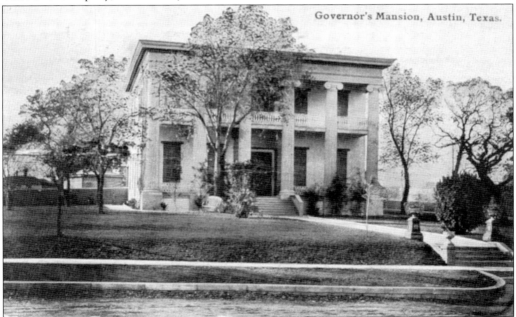

GOVERNOR'S MANSION, POSTMARKED 1913. This card is distinguished by the dirt road (Colorado Street) and the granite curb along the roadway. The Governor's Mansion is bounded by Colorado, Hickory (Tenth), Lavaca, and Mulberry (Eleventh) Streets. It was originally built for $15,000 plus a $2,000 allowance for the furnishings. (Published by R. E. Warren, Austin.)

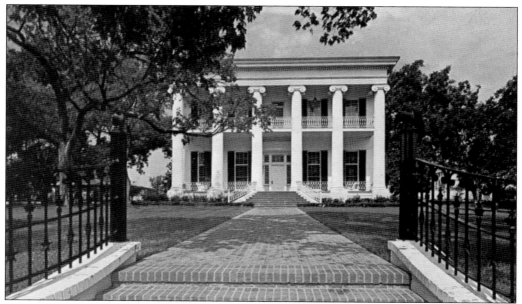

GOVERNOR'S MANSION. A new kitchen was installed in the early 1900s and air-conditioning in the 1950s. In 1980, Gov. William Clements oversaw a major renovation of the house and grounds. Another full renovation was started in 2008, including the addition of a fire control system and upgraded security. Unfortunately the structure was severely damaged that same year by an apparent arsonist. (Published by Armstrong's Western Fotocolor, Fort Worth.)

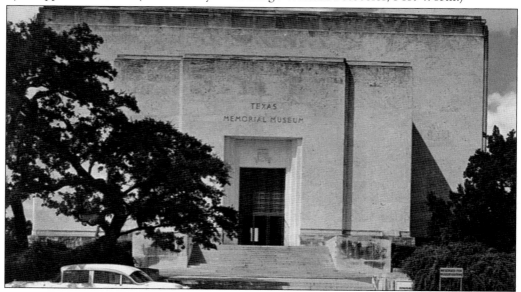

TEXAS MEMORIAL MUSEUM. Austin's first public museum was completed in 1938 at 2400 Trinity Street. Now a part of the University of Texas, it houses popular exhibits as well as scientific research in areas of Texas geology, paleontology, and anthropology. The *Mustangs* statue on Trinity Street was added in 1948. But note that the building entrance is actually on the opposite side of the structure. (Published by Austin News Agency, Austin, and Colourpicture Publishers, Inc.)

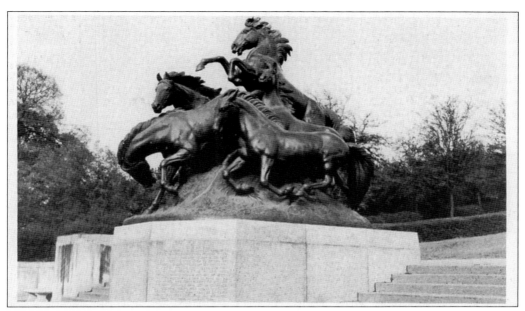

MUSTANGS (**WHITE-BORDER CARD**). The statue *Mustangs* at the Texas Memorial Museum was sculpted by Alexander Phimister Proctor and was dedicated on May 1, 1948. Ralph Ogden of Austin donated funds for the statue, and J. Frank Dobie recommended Proctor as the sculptor. Part of Proctor's work was done at the King Ranch, where he used wild mustangs as models. (Publisher unknown.)

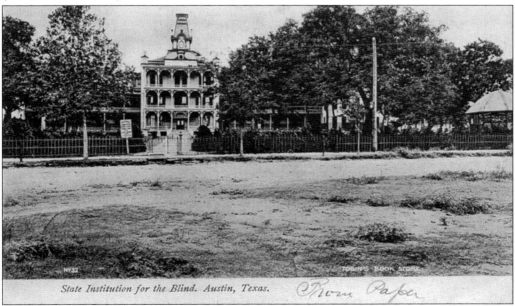

State Institution for the Blind. Austin, Texas.

INSTITUTION FOR THE BLIND (**UNDIVIDED BACK**), C. **1900.** This building is particularly famous for having been occupied in 1865 by Gen. George Armstrong Custer and his force of army volunteers during the Union military occupation of Austin following the Civil War. The building is now part of what is known as the "Little Campus" of the University of Texas and serves as a visitor center for the university. (Published by Tobin's Book Store, Austin.)

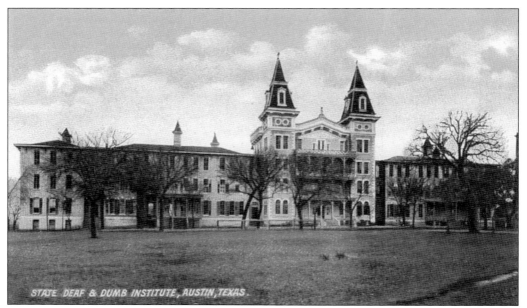

INSTITUTION FOR THE DEAF AND DUMB. The State School for the Deaf and Dumb was established in 1857. By 1923, it was reported to be the second largest school for the deaf in the country and offered courses in a variety of trades as well as academic instruction. The facility is located on South Congress, about a quarter-mile south of the Colorado River—still its location today. (Published by Von Boeckmann–Jones Company, Austin.)

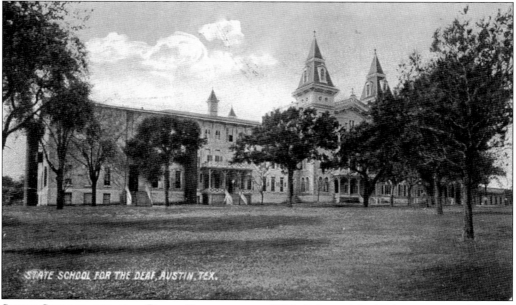

STATE SCHOOL FOR THE DEAF, POSTMARKED 1910. Substantial additions were made to the original structure from 1875 to the 1880s. Also the method of instruction was changed from a strictly manual form of communication to a combined manual and oral system in use today. In 1949, the name was officially changed to the Institution for the Deaf. (Published by the Rotograph Company, New York and Germany.)

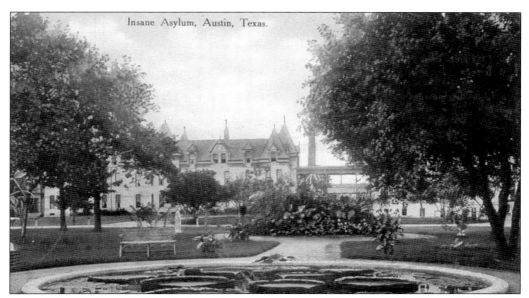

INSANE ASYLUM. In the early days, the state went to great lengths with substantial building programs to care for those with disabilities (for example, the blind, deaf and dumb, and the insane). The Insane Asylum (later called the State Institution for the Insane and later still the Austin State Hospital) at 4110 Guadalupe Street was built in 1861 at a cost of $50,000 for the land and buildings. It was the first such institution built west of the Mississippi. (Published by R. E. Warren, Austin.)

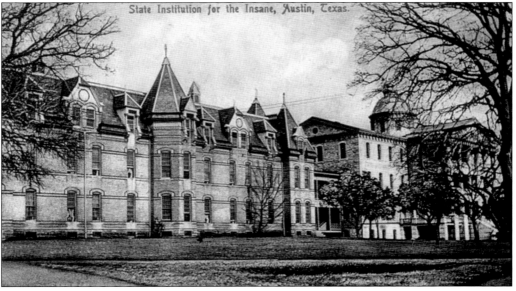

STATE INSTITUTION FOR THE INSANE. There must have been great interest in the State Institution for the Insane because a great number of postcards exist, each with a different view or detail. This postcard, postmarked 1909, shows the two primary buildings, located along Guadalupe Street. The 1960s development of clinical psychiatry and psychology led to a significant decline in the number of patients in state hospitals. (Published by Sauter and Kuehne, Austin.)

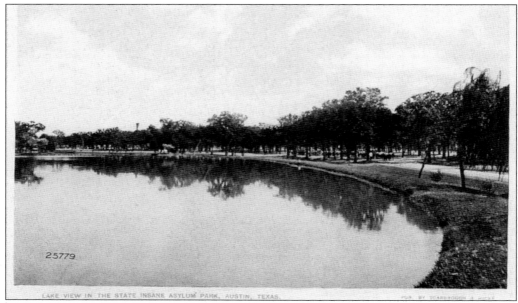

ASYLUM PARK, POSTMARKED 1910. Before 1861, individuals with a mental illness or mental retardation were kept at home, sent out of state for treatment or custodial care, or confined in jails. The three asylum facilities that Texas built—first in Austin, then in Terrell and San Antonio—were each a place for peaceful relaxation yet confinement. A substantial lake and other facilities were added over the years. (Published by Scarborough and Hicks, Austin.)

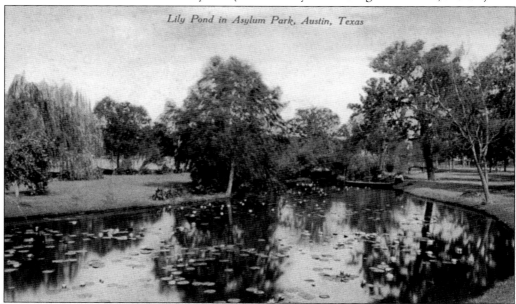

LILY POND IN ASYLUM PARK. At the time, it was thought that rest and relaxation was a significant part of the cure for mental illnesses. The Asylum for the Insane (later the Austin State Hospital) had beautiful grounds, which included this pond with water lilies. Today Central Park in Austin offers a similar lake near the original Asylum Park pond. (Published by E. P. Jordan, Austin.)

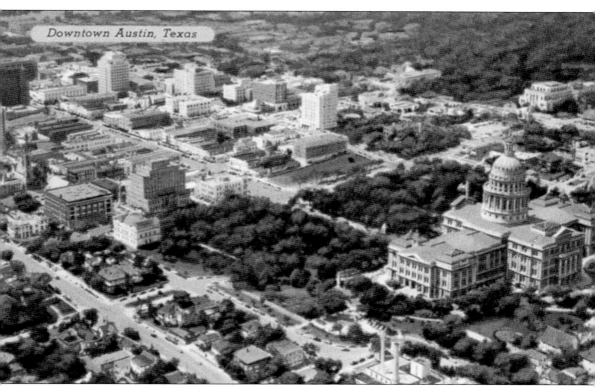

Downtown Austin, Texas

DOWNTOWN AUSTIN. This *c.* 1940 aerial photograph shows the State Highway Building (1933), catty-corner to the General Land Office (1857), and the lush foliage on the capitol grounds. Downtown is beginning to have some taller buildings, such as the Norwood Tower, the Highway Department Building, and the Travis County Courthouse. (Published by Austin News Company, Austin; Colourpicture, Boston, Massachusetts.)

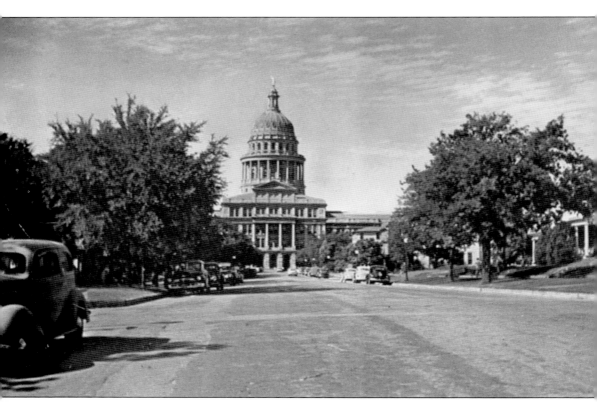

CAPITOL BUILDING FROM THE NORTH. This chapter began with the images of the capitol, all of which showed the south entrance, the main and ceremonial entrance to the capitol. The chapter will close with a rarer image from the north. In the 1980s and 1990s, major state office buildings were added to the north of the capitol on either side of Congress Avenue. (Published by Colourpicture Publishers, Inc., Boston.)

Four

AROUND TOWN

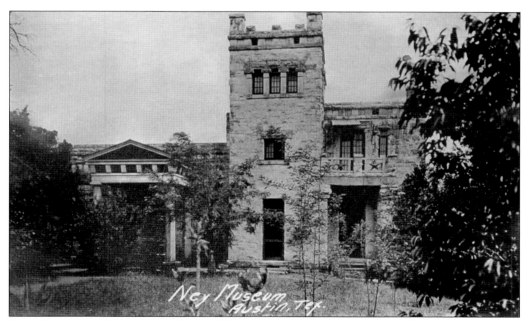

NEY MUSEUM (UNDIVIDED-BACK RPPC). Celebrated European sculptress Elisabet Ney moved to Austin in 1892 and opened a small studio in Hyde Park. Her castle-like studio, called Formosa, housed her collection of European work. Ney's life-sized sculptures of Sam Houston and Stephen F. Austin stand today in the state Capitol Building, and copies are also located in the U.S. Capitol. The studio is now the Ney Museum. (Real-photo postcard; publisher unknown.)

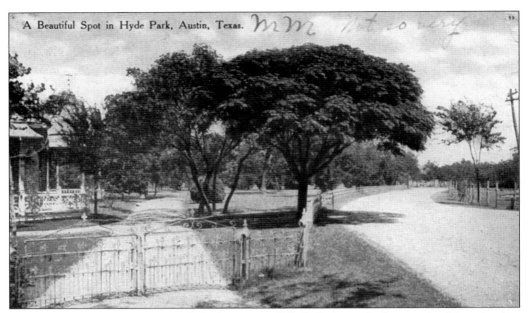

HYDE PARK. Numerous postcards depict scenes of Hyde Park, no doubt a result of the relentless promotion of real estate developer Monroe Shipe, a shrewd businessman who worked to lure new residents to his upper-tier residential community just north of town (north of Thirty-eighth Street). Shipe turned what was the former state fairgrounds into a housing resort with lakes, a skating rink, and tennis and croquet courts. (Published by R. E. Warren, Austin.)

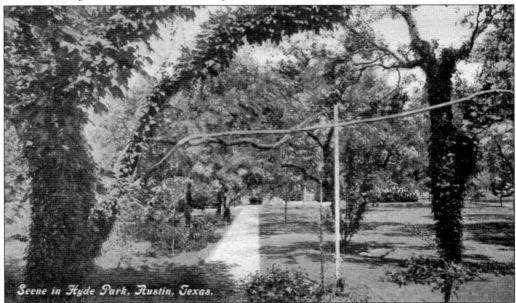

SCENE IN HYDE PARK, POSTMARKED 1910. Parts of Hyde Park had previously been a racetrack, and part of the existing grandstand was reutilized for outdoor performances. Even UT football games were played at times in Hyde Park. Walkways were built throughout the subdivision, and gravel roads were promoted for their ability to keep dust down. Shipe hooked up his own moonlight tower months before the City of Austin lighted their towers. (Publisher unknown.)

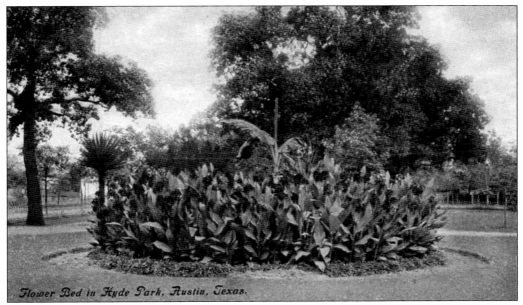

FLOWER BED IN HYDE PARK, POSTMARKED 1910. The subdivision featured two man–made lakes created by damming up Waller Creek. The large lake, Gem Lake, featured water lilies and had boats for rowing. Shipe also planted trees and significant landscaping, which he maintained along with the roads in order to promote the high quality of the development. (Published by Abe Frank, Austin.)

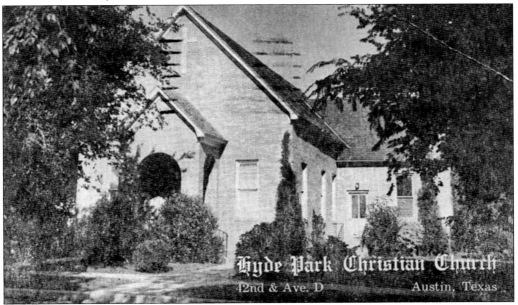

HYDE PARK BAPTIST CHURCH, POSTMARKED 1943. In the early 1940s, Hyde Park Baptist Church (shown in this "Buy War Bonds" cancellation) was established at Forty-second Street and Avenue D. Over the years, it has become one of the largest churches in Austin still located in the inner city, expanding over several blocks, and now includes a parking garage in Hyde Park. A second, remote facility was later added in far northwest Austin. (Publisher unknown.)

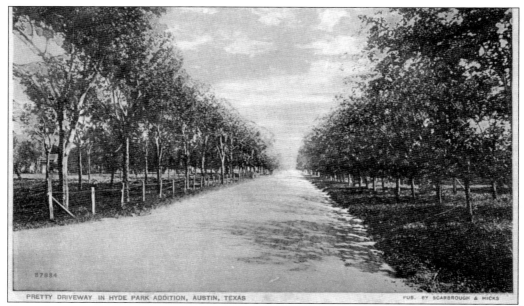

PRETTY DRIVEWAY IN HYDE PARK ADDITION, AUSTIN, TEXAS PUB. BY SCARBROUGH & HICKS

HYDE PARK—TREE-LINED DRIVE (UNDIVIDED BACK). Hyde Park developer Monroe Shipe built Speedway, a road to provide fast, easy, and direct access between downtown and Hyde Park and which he named to reflect its quick access. The roads within Hyde Park were well landscaped and inviting, as seen in this postcard. (Publisher unknown; Austin History Center, Austin Public Library.)

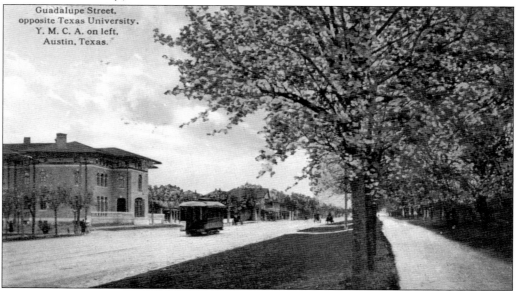

Guadalupe Street,
opposite Texas University.
Y. M. C. A. on left,
Austin, Texas.

GUADALUPE TROLLEY, POSTMARKED 1913. Shipe also won the franchise to provide the first electric streetcars in Austin in 1890, which he quickly extended to Hyde Park as a faster and more reliable alternative to the previous mule-drawn streetcars. But by the late 1930s, the growth in ownership of automobiles and aggressive citywide street paving brought the streetcar era to a close. (Published by S. H. Kress and Company; Austin History Center, Austin Public Library.)

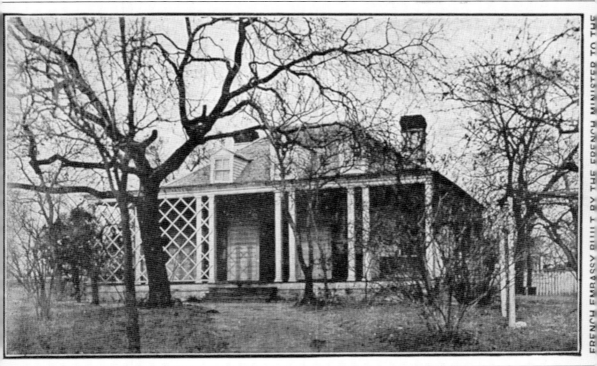

THE "PIG WAR." Prior to the Republic of Texas joining the United States, the French government dispatched Jean Peter Isidore Alphonse Dubois, Comte de Saligny, from the French legation in Washington to the new Republic. Dubois stayed only a short time in Texas but issued a favorable report back to King Louis Phillipe recommending the king recognize Texas as a country, which he did in 1939. Dubois was then formally dispatched to Texas to open a legation in Austin in a house built for him and for his lavish lifestyle. The home was built in 1840–1841 on a 21-acre estate on a hill east of downtown. It featured elegant hardware, elaborate French millwork, and a wine cellar and was furnished with French furniture and fine linens. Although relations had started out well, they began to deteriorate rapidly in early 1841 as suspicions arose that French entrepreneurs would profit handsomely from a proposed Franco-Texian bill that Dubois promoted allowing French colonists to settle portions of West Texas. Matters were made worse when pigs owned by a well-known innkeeper, Richard Bullock, raided Dubois's garden. Dubois ordered his assistant to shoot any pigs on his property, which he did, killing a number of them, earning a beating by their owner and a warning that Dubois would be next should Bullock lose more livestock. This "Pig War" sparked considerable legal and political battles both at home and abroad, with France officially protesting over the incident and de Saligny refusing to appear before a Texas court. Dubois eventually picked up his passport and fled to New Orleans. Dubois spent the rest of his time in New Orleans conducting Texas business with occasional trips to Houston, Galveston, and Washington-on-the-Brazos. (Postcard published by William B. Travis Chapter, Daughters of the Republic of Texas.)

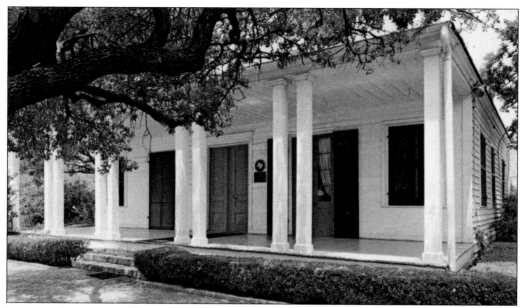

FRENCH LEGATION. The French Legation home was built in 1840–1841 using loblolly pine from Bastrop and was subsequently sold to several owners, including Dr. Joseph W. Robertson. The area is known today as Robertson Hill. In 1948, the legation was placed into the custody of the Daughters of the Republic of Texas, who restored the house, extensively landscaped the property, and operate a museum. (Published by Austin News Agency, Austin.)

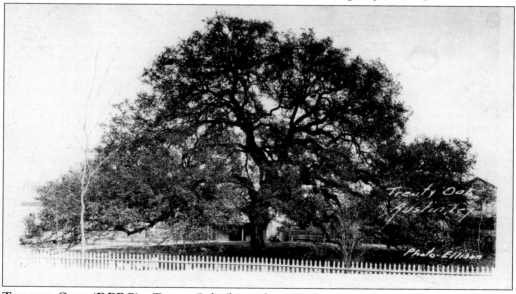

TREATY OAK (RPPC). Treaty Oak (located on Baylor Street between Fifth and Sixth Streets) is believed to be more than 500 years old and is said to be the place where Stephen F. Austin signed a boundary treaty between the Anglos and the Native American tribes. The tree holds many records, including "the most perfect specimen tree" in the United States. Unfortunately the tree was deliberately poisoned in 1989, and only about a third of the tree remains. (Photograph by Ellison; publisher unknown.)

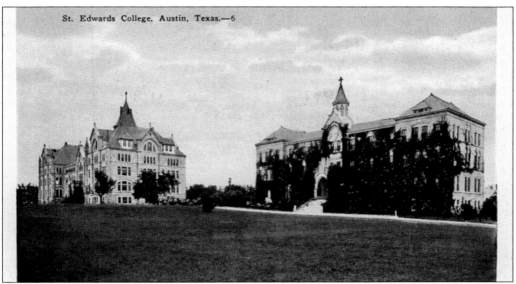

ST. EDWARD'S COLLEGE (UNDIVIDED BACK), POSTMARKED 1905. St. Edward's was founded by Rev. Edward Sorin of the Holy Cross Fathers and Brothers. Father Sorin also established the University of Notre Dame in the 1840s and a college in Galveston in 1870 before coming to Austin. In 1889, the Old Main style of building, designed by Galveston architect Nicholas J. Clayton, was constructed. In 1925, it was re-chartered as St. Edward's University. (Published by E. C. Kropp Company, Austin.)

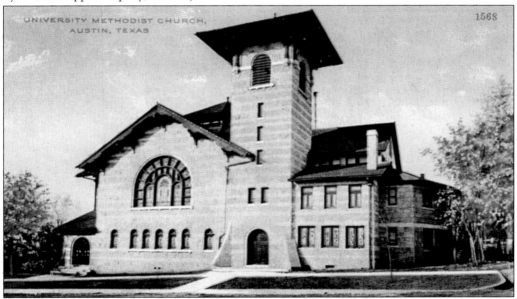

UNIVERSITY METHODIST CHURCH. Currently located at 2409 Guadalupe Street in a small out parcel of the University of Texas, the church was originally founded in 1887 as Twenty-fourth Street Methodist Church at Twenty-fourth Street and Whitis Avenue, on the edge of the UT campus. The University of Texas was only three years old at the time. Then in 1909, the church moved to the current site and was renamed University Methodist Church. (Published by S. H. Kress and Company.)

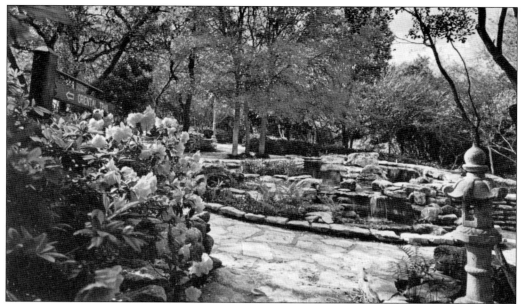

ZILKER GARDENS. Within the Zilker Botanical Gardens, on a hill overlooking Zilker Park, a dramatic Japanese garden was constructed by Isamu Taniguchi, his gift to the City of Austin, as a place of tranquility and enjoyment. In his retirement, Taniguchi built the Japanese gardens, koi ponds, a tea room, a moon bridge, a boat, and even ponds that spell "Austin." (Published by Austin News Agency, Austin.)

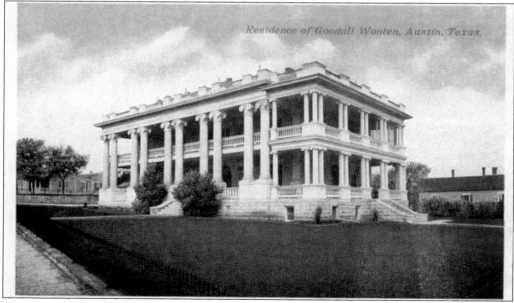

RESIDENCE OF GOODALL WOOTEN. Located on Nineteenth Street, the Goodall Wooten residence was built in 1898–1900 for local doctor and benefactor Goodall H. Wooten. In the 1960s and 1970s, it suffered years of neglect as a student residency hall, then was a drug treatment center. It is now a luxury hotel—The Mansion at Judge's Hill. The building was added to the National Register of Historic Places in 1975. (Publisher unknown.)

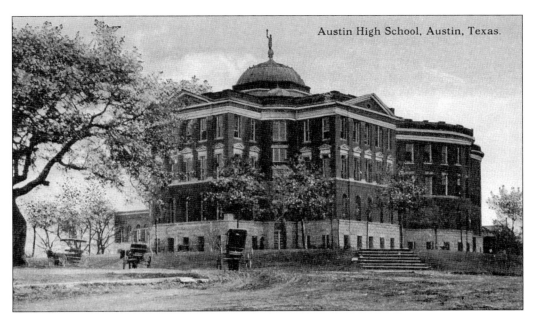

AUSTIN HIGH SCHOOL, POSTMARKED 1912. Austin High School was founded in 1881 and is one of the oldest public high schools in the state. Located at Ash (Ninth) and Trinity Streets, the first permanent structure was this handsome red-brick building. The building was used for the high school until 1925, and it burned in 1956. Note the ruts in the road cut by the horse-drawn carriages. (Publisher unknown; Waneen Spirduso collection.)

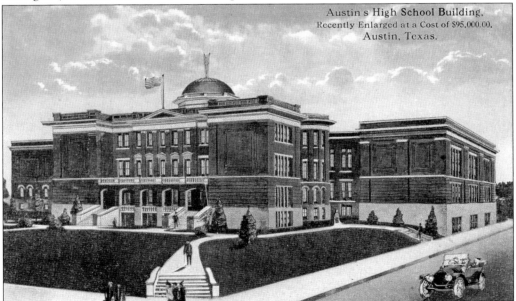

AUSTIN HIGH SCHOOL ENLARGED. "Recently enlarged at a cost of $50,000" reads the caption on the reverse. By this time, sidewalks have also been added and the roads paved, and the automobile has replaced the horse and buggy for transportation. This building was known affectionately by students as "Old Red" for the deep red-brick color. (Published by Abe Frank, Austin, C. T. Photochrom; Waneen Spirduso collection.)

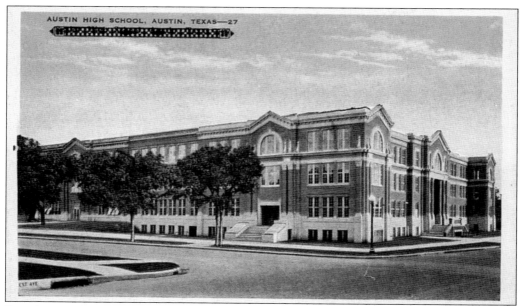

RIO GRANDE CAMPUS. In 1925, Austin High School moved into a former junior high location at 1212 Rio Grande Street. Note that when the change was made, the postcard printer simply crossed out the previous junior high caption. Then in 1975, the high school moved into its current lakeside location. The 1212 Rio Grande Street facility still exists and is a campus of Austin Community College. (Published by E. C. Kropp Company, Milwaukee.)

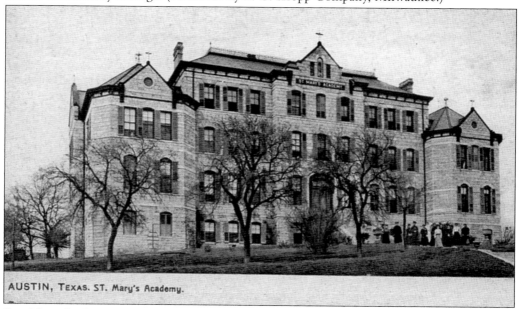

AUSTIN, TEXAS. ST. Mary's Academy.

ST. MARY'S ACADEMY (UNDIVIDED BACK). The Sisters of Holy Cross opened the first Catholic secondary school for young women, St. Mary's Academy, in Austin in 1874. As enrollment increased, the building was enlarged and then a new four-story limestone school was constructed in 1885 (shown here) on land bounded by East Seventh, Brazos, East Eighth, and San Jacinto Streets. The building was later razed. (Published by Raphael Tuck and Sons.)

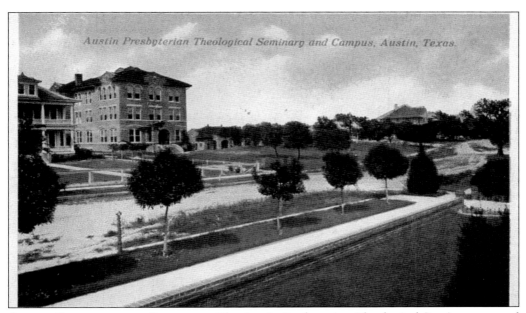

AUSTIN PRESBYTERIAN SEMINARY. The Austin Presbyterian Theological Seminary opened its doors on October 1, 1902. By 1908, an expanded campus (shown here) was added near the University of Texas on East Twenty-seventh Street and Speedway on a five-acre plot, large enough to allow additional buildings and apartments for students to be built. Today the campus has been enlarged to 10 acres. (Publisher unknown.)

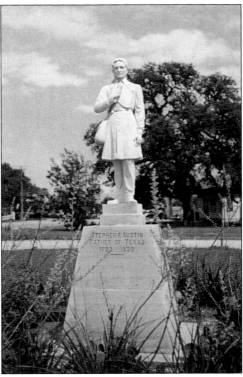

STATUE OF STEPHEN F. AUSTIN. This statue of Stephen F. Austin is located on South Congress Avenue. Austin is commonly known as the "Father of Texas" and lived from 1793 to 1836. He was the first person to negotiate land grants from Mexico and to bring U.S. immigrants to settle the area that is now Texas. Some 900 families were relocated to Texas through his direct efforts. (Published by Don R. Bartels, McAllen.)

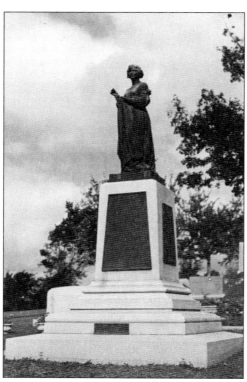

JoAnna Troutman Statue. This monument by Pompeo Coppini marks the grave of JoAnna Troutman (1818–1880) in the state cemetery. She is most noted for having made the first Texas Lone Star Flag—a white silk flag with a blue five-pointed star with the words "Texas and Liberty" used in the battle at Goliad. Her portrait also hangs in the state capitol. (Published by Don R. Bartels, McAllen.)

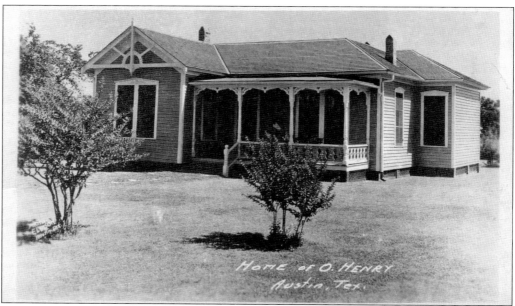

O. Henry Home (RPPC). Originally located at 308 East Cedar (Fourth) Street, this was the home of William S. Porter, also known as writer O. Henry, possibly Austin's most famous author. The four-room structure was later relocated to Pine (Fifth) and Trinity Streets at Brush Square and restored. It is now the O. Henry Museum and is furnished with many of Porter's original belongings. (Publisher unknown.)

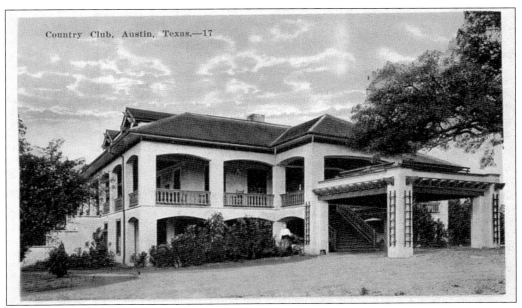

Country Club, Austin, Texas.—17

AUSTIN COUNTRY CLUB. The Austin Country Club founded in 1899 is one of the oldest county clubs still in existence in Texas and perhaps is the first of its kind in Texas. Founded by former mayor Lewis Hancock, the initial membership list contained most of the early pioneer families of Austin and read like a Who's Who of Austin society. Hancock chaired the club for 17 years. (Published by S. H. Kress and Company.)

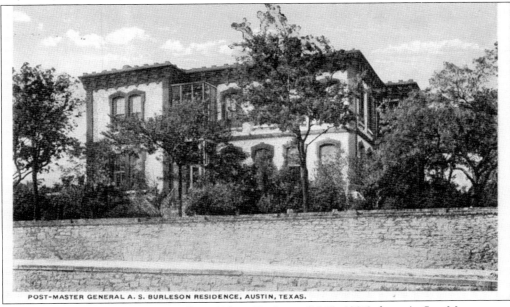

POST-MASTER GENERAL A. S. BURLESON RESIDENCE, AUSTIN, TEXAS.

A. S. BURLESON RESIDENCE. Albert Sidney Burleson (1863–1937), born in San Marcos, was an attorney and congressman. He was appointed U.S. postmaster general by Woodrow Wilson in 1913, a post he held until 1921. During his tenure, the U.S. Post Office developed the parcel post and air mail services and increased mail service to rural areas. (Published by Abe Frank, Austin; C. T. American Art.)

LAGUNA GLORIA ART MUSEUM. The Laguna Gloria Art Museum is located at the end of West Thirty-eighth Street, on land once selected by Stephen F. Austin for his own residence. The existing Mediterranean villa–style home was erected by Henry and Clara (Driscoll) Sevier overlooking Lake Austin. Clara Driscoll gave the land and building to the Texas Fine Arts Association for use as a museum. (Published by Weiner News Company, San Antonio.)

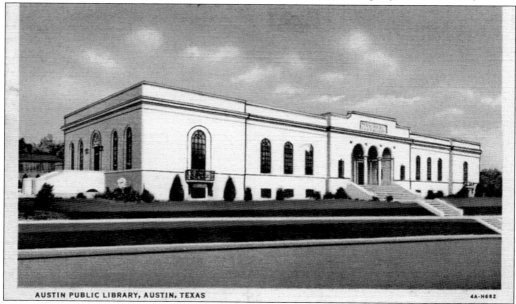

AUSTIN PUBLIC LIBRARY, AUSTIN, TEXAS 4A-H682

AUSTIN PUBLIC LIBRARY. This postcard exemplifies the style of the Curt Teich Company (Chicago) in using an actual photograph but stylizing it with their signature clean, simplified, airbrushed look. The Austin Public Library opened in 1933 and at the time served 10,000 borrowers. It faces Wooldridge Park and the county courthouse. Today it is the home of the Austin History Center. (Published by Curt Teich and Company, Chicago; C. T. Art Colortone.)

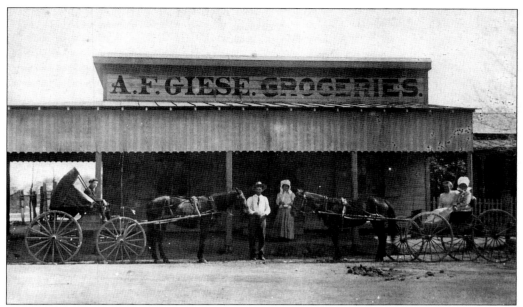

A. F. Giese Groceries. Little information is available about this business except that the building still stands today (albeit empty) at 1211 San Bernard Street in east Austin. The real-photo postcard (RPPC) captures a moment in time from the early 1900s before the automobile. RPPCs are relatively scarce but give some of the most interesting glimpses into life during this earlier time. (Ned Coleman collection.)

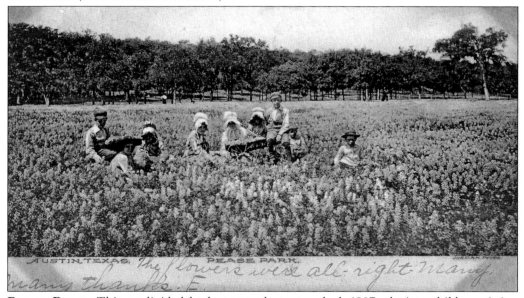

Pease Park. This undivided-back postcard, postmarked 1907, depicts children sitting in bluebonnets at Pease Park. Pease Park today is a 42-acre city park located along Lamar Boulevard and bisected by Shoal Creek. It is best known for the annual Eeyore's Birthday Party celebration each spring. Today Austinites still photograph their children sitting in the bluebonnets, usually in a patch of bluebonnets alongside a highway. (Publisher unknown; Waneen Spirduso collection.)

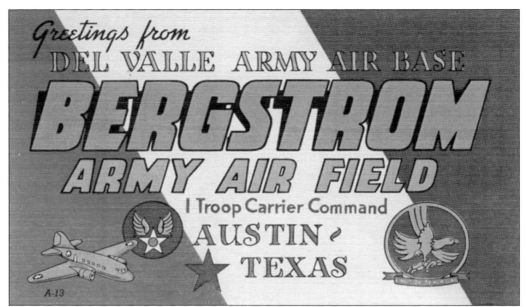

BERGSTROM ARMY AIR FIELD. Later Bergstrom Air Force Base, the army air field was located in Del Valle, on the southeast border of Austin. Austinites raised the money for the airfield during World War II and donated the land for its construction. Because the land was originally purchased by Austin, the base reverted to the city's ownership when it was decommissioned. It is now the home of Austin Bergstrom International Airport (ABIA). (Published by Hausler–Kilian Cigar and Candy Company, Austin.)

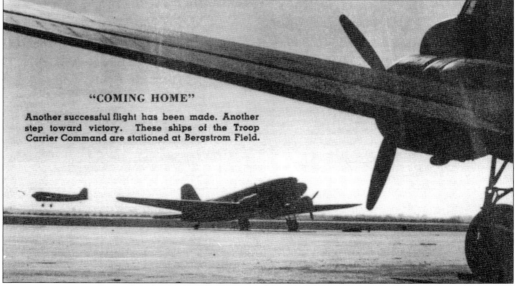

"COMING HOME"

Another successful flight has been made. Another step toward victory. These ships of the Troop Carrier Command are stationed at Bergstrom Field.

"COMING HOME." Bergstrom Field was named to honor Capt. John E. A. Bergstrom, Austin's first casualty in World War II. Captain Bergstrom was killed December 8, 1941, the day following the Japanese attack on Pearl Harbor, which marked the U.S. entry in the war. He was a reserve officer in the Army Air Force and was killed in the strafing of Clark Field in the Philippine Islands. (Publisher unknown.)

**BERGSTROM AIR FORCE BASE (1942–
1993).** Bergstrom was well known to
Austinites by its circular Strategic Air
Command building and its distinctive
control tower. In the later years, the
country's largest and longest-range bombers
flew in and out of the field as the airfield
was a frontline Strategic Air Command
base during the cold war. It also housed
the air force's reconnaissance fighter fleet.
(Published by Austin News Agency, Austin.)

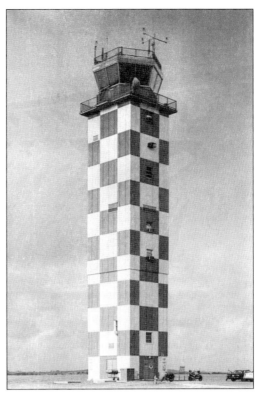

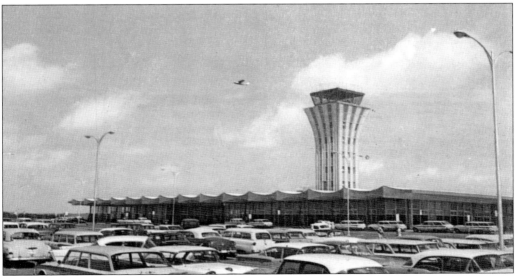

AUSTIN MUELLER AIRPORT. Another distinctive control tower loomed over Austin's 740-
acre municipal airport. Mueller served Austin's general aviation needs until it was replaced in
1993 by the new Austin Bergstrom International Airport. Today the site is being converted
to a new urban development of housing, retail, the Dell Children's Hospital, research and
commercial uses, and parks. The control tower itself will remain as a symbol of the new
residential community. (Published by Austin News Agency, Austin.)

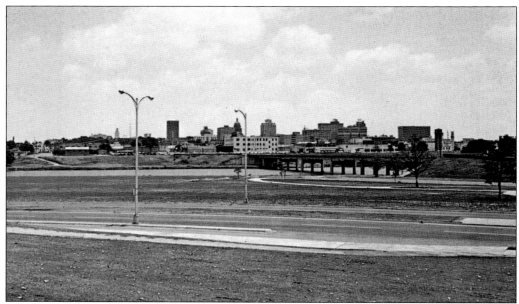

COLORADO RIVER. This and the next several postcards are from the 1950s and depict an Austin that few remember today. This photograph is from the south shore of the Colorado River (now Lady Bird Lake) looking north, showing the shoreline at Congress Avenue, before the efforts to create Town Lake Park—an effort begun by Lady Bird Johnson. Today a pavilion and pond sit at this approximate site. (Published by Don Bartels, McAllen.)

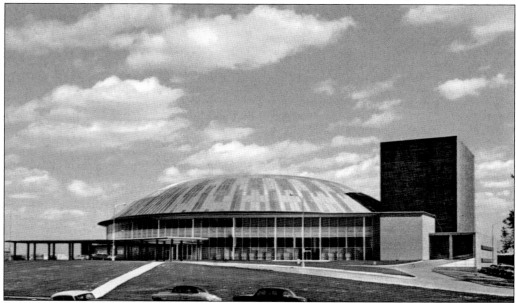

MUNICIPAL AUDITORIUM. On the south side of the river, located as part of "Auditorium Shores," was Austin's Municipal Auditorium and Convention Center, known for its distinctive green roof panels and the brick curtain loft behind. Today the building has been reconstructed as the Joe R. and Theresa Lozano Long Center for the Performing Arts, in which most of the panels have been cleverly reused and recycled. (Published by Austin News Agency, Austin.)

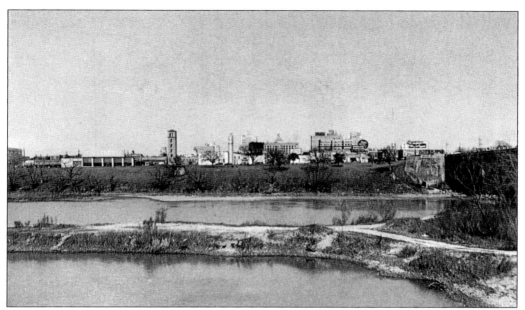

SKYLINE FROM MUNICIPAL AUDITORIUM. The skyline of 1950 is a far cry from that of today. The capitol is barely visible from this angle, to the right of the Norwood Tower. The prominent training "fire tower" still exists today. Town Lake is in the foreground along with the First Street bridge. No work had yet been done on Town Lake Park or creation of the trail system. (Published by Austin News Agency, Austin.)

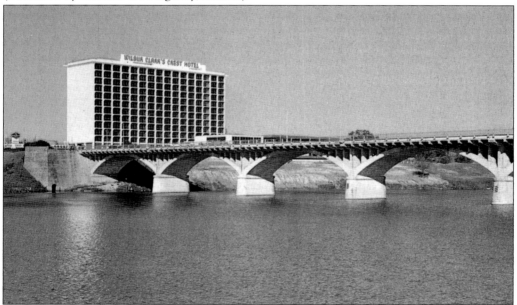

WILBUR CLARK'S CREST HOTEL. Las Vegas casino owner Wilbur Clark, owner of the Desert Inn, built the Crest Hotel in Austin. It was later foreclosed and then became the Sheraton Crest Hotel. The hotel was constructed by contractor Del Webb of Las Vegas, who was to become the developer of the popular Sun City community concept. (Published by Austin News Agency, Austin; Waneen Spirduso collection.)

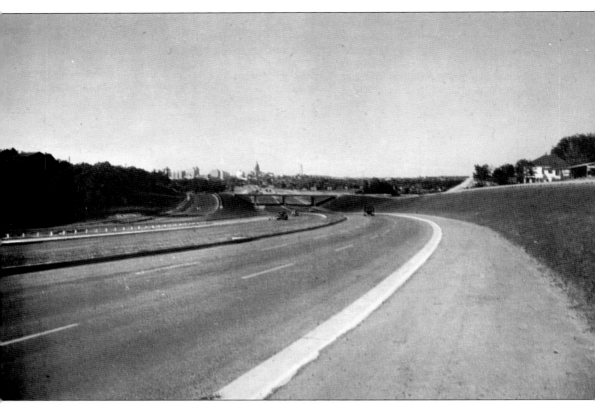

INTERREGIONAL HIGHWAY. U.S. 81 Expressway, also known locally as the "Interregional Highway," was Austin's first freeway (and is today Austin's worst freeway). It is what is known today as Interstate 35. Completed in June 1954, it runs through downtown Austin along what was formerly East Avenue. This view from the south looking toward the Riverside Drive overpass and on to downtown is almost totally devoid of traffic. (Published by Baxtone, Amarillo.)

Five

THE UNIVERSITY OF TEXAS

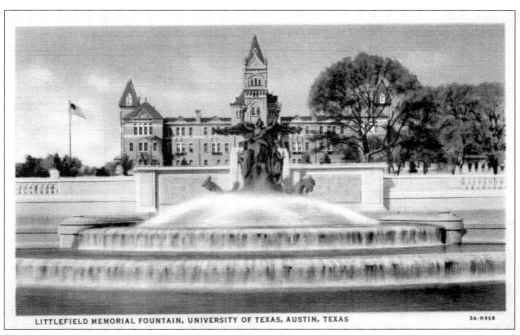

LITTLEFIELD MEMORIAL FOUNTAIN, UNIVERSITY OF TEXAS, AUSTIN, TEXAS 3A-H458

THE UNIVERSITY OF TEXAS, C. 1933. This will be a surprising postcard to many. Rather than the iconic UT "Tower," this card shows the original Old Main Building behind the Littlefield Memorial Fountain. There was a brief period of time between when the Littlefield Fountain was completed in 1932 and when the Old Main Building was razed in 1935 to make way for the current administration building with its landmark UT Tower. (Published by Curt Teich and Company, Chicago.)

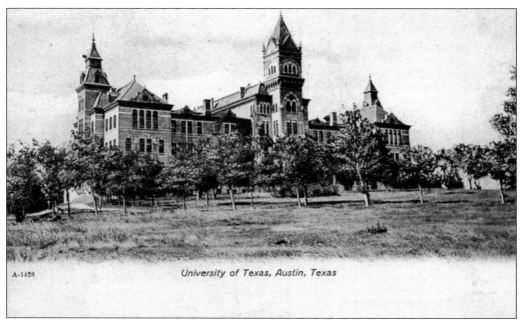

University of Texas, Austin, Texas

OLD MAIN (UNDIVIDED BACK). This was the first building at the University of Texas in Austin, which housed administration offices as well as classrooms and a small library. The building sat atop a hill in the center of 40 acres of land set aside for the UT campus, located less than a mile from the state capitol. (Published by S. Langdorf and Company, New York.)

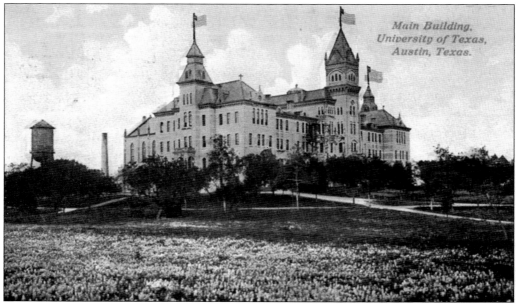

Main Building, University of Texas, Austin, Texas.

THE UNIVERSITY OF TEXAS AT AUSTIN. The University of Texas is the flagship institution of the University of Texas System. Founded in 1883, the university has recently had the largest enrollment in the country, with over 50,000 undergraduate and graduate students and 16,500 faculty and staff. The university campus opened with Old Main as its first and only building, although some classes were held before then in the state capitol. (Publisher unknown.)

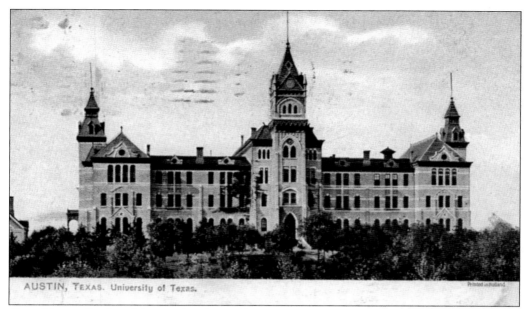

AUSTIN, TEXAS. University of Texas.

OLD MAIN. Designed by Frederick Ruffini (originally of Cleveland and later of Austin), Old Main was an imposing and impressive building for its time. Of the many other Ruffini-designed buildings in Austin, only one remains in existence—the Millett Opera House—now much altered and home to the Austin Club (on Ninth Street, east of Congress). (Published by Raphael Tuck and Sons.)

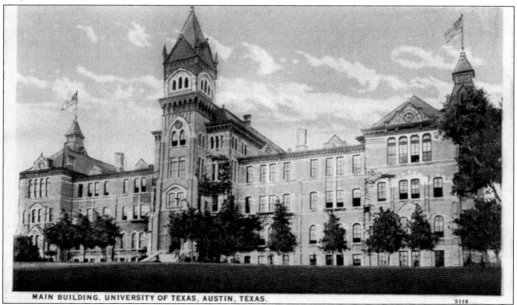

MAIN BUILDING, UNIVERSITY OF TEXAS, AUSTIN, TEXAS.

THE UNIVERSITY OF TEXAS. Although the cornerstone was laid in 1882, the entire building was not completed until 1899. (The West Wing was completed and occupied in 1884.) The building was planted with ivy imported from England. Tower chimes, donated by U.S. postmaster general A. S. Burleson, were added in 1930 to call out the hour. (Published by Abe Frank Cigar Company, Austin.)

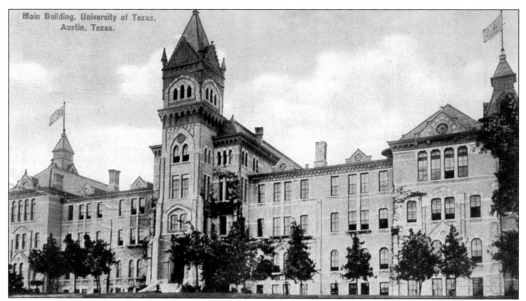

CONSTRUCTION OF OLD MAIN, POSTMARKED 1910. Although Frederick Ruffini was the architect, the contract for construction of the building was given to Abner Cook. Cook was already well known in Austin for his design and construction of the Governor's Mansion, Woodlawn (Governor Pease's residence), and the Neill-Cochran House, among others. Due to financial constraints, the regents had to limit construction to only one-third of the building at a time. (Published by Abe Frank, Austin.)

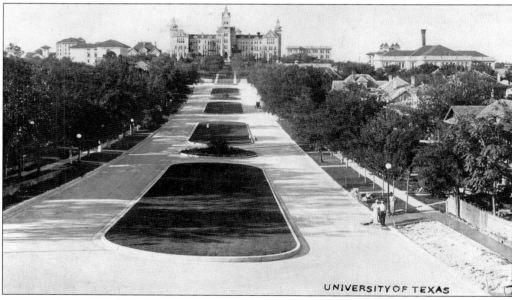

UNIVERSITY DRIVE (RPPC). Old Main (and now the current UT Main Building and Tower) sits on the axis of University Drive, making for an impressive view of the university campus. Here workmen complete a driveway and sidewalk. In 2008, a university-sponsored conference center and hotel was built on University Drive just to the left of this image—known as the AT&T Executive Education and Conference Center and Hotel. (Publisher unknown.)

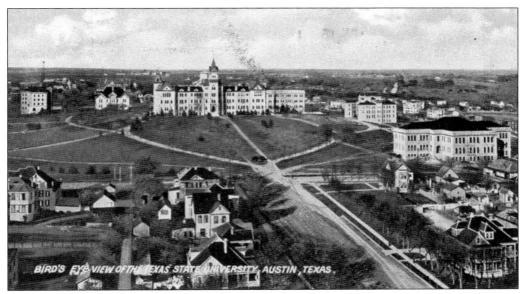

BIRD'S-EYE VIEW OF THE UT CAMPUS. This early-1900s aerial view of the campus (postmarked 1905) shows the buildings that had been constructed. The Old Law Building sits on the near right and Garrison Hall is behind. The Women's Building (which later burned in 1959) is on the left along with Battle Hall. The Littlefield Fountain had not been constructed, and walkways were mere paths at the time. (Published by Von Boeckmann Company, Austin.)

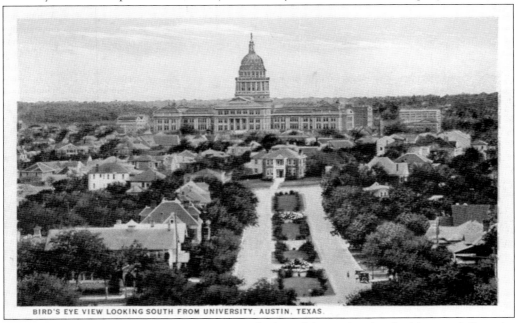

BIRD'S-EYE VIEW LOOKING SOUTH. In its early days, this was the view looking south from the Main Building, down University Drive. The area between the university and the state capitol was predominately residential with many houses serving as homes of university professors. The house at the apex of University Drive and Nineteenth Street no longer exists. (Published by Abe Frank, Austin.)

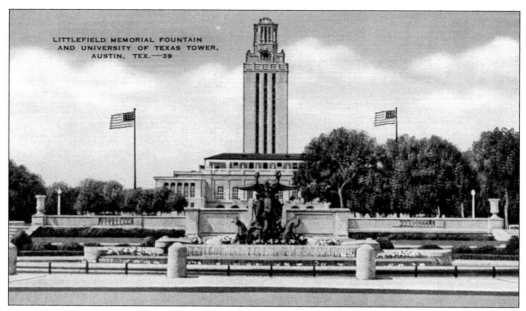

THE UNIVERSITY OF TEXAS TOWER. Old Main was razed in 1935 to make way for a larger administrative building and the UT Tower, which served as a library. This is the familiar sight of today with the UT Tower, a notable landmark, situated behind the Littlefield Memorial Fountain. The tower is lit in different schemes at times to celebrate various athletic and academic achievements. (Published by E. C. Kropp Company, Milwaukee.)

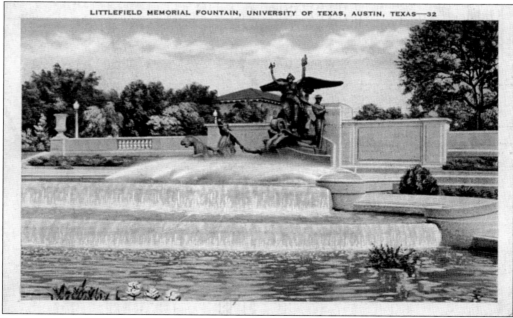

LITTLEFIELD MEMORIAL FOUNTAIN. The fountain is of bronze, executed by Pompeo Coppini. The ledges over which the water flows are Texas pink granite. It, and four other statues on the Main Mall, were a gift from Maj. George W. Littlefield—cattleman, banker, and member of the Board of Regents—at a cost of $250,000. (Published by Austin News Agency, Austin.)

UNIVERSITY TOWER. At the time of construction, folklorist and UT professor J. Frank Dobie called the tower inappropriate architecture, into which he refused to move, saying it "looks like a toothpick in a pie, and ought to be laid on its side and have galleries put around it." "With as much room as we have in Texas, and as many acres of land as the University owns we have to go and put up a building like those in New York City," lamented Dobie in his class on Southwest literature. Nevertheless, the tower has become a much cherished symbol of the university. (Published by Hausler–Kilian Cigar and Candy Company, Austin.)

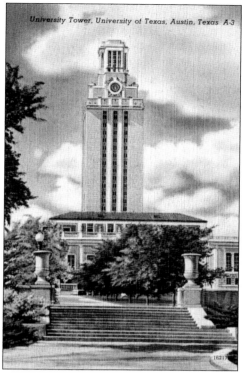

University Tower, University of Texas, Austin, Texas A-3

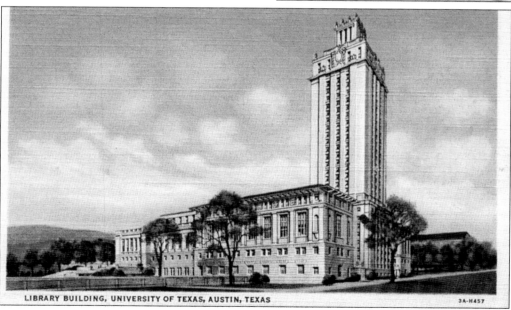

LIBRARY BUILDING, UNIVERSITY OF TEXAS, AUSTIN, TEXAS 3A-H457

MAIN BUILDING AND TOWER. The present Main Building and tower were completed in 1937 at the site of Old Main, which was demolished for the new construction. Designed by architect Paul Cret, it is built in a Spanish Renaissance style, as were several other UT buildings that came after it. Seventeen bells originally hung in the tower, later expanded to a full carillon of 56 bells. (Published by Ellison, Austin.)

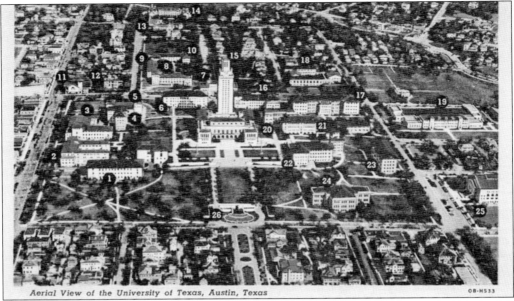

Aerial View of the University of Texas, Austin, Texas

08-H533

AERIAL VIEW OF THE UNIVERSITY OF TEXAS. This aerial view is dated around 1930. By this time, the Littlefield Memorial Fountain had been built, along with University Drive and some 26 buildings and features that were individually identified, including Gregory Gymnasium (number 25), built in 1930. (Published by Austin News Agency; Curteich-Chicago "C. T. Art-Colortone.")

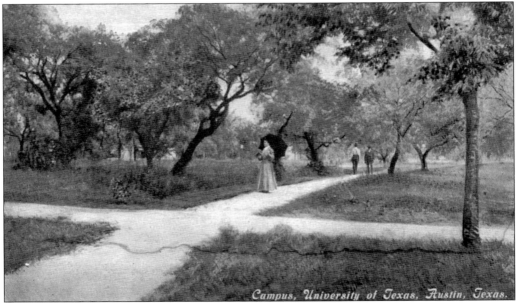

Campus, University of Texas, Austin, Texas.

THE UNIVERSITY OF TEXAS CAMPUS, POSTMARKED 1916. The early campus consisted of open fields. Walkways were mere dirt paths. Later many sidewalks were added and lined with trees. The original campus was built on 40 acres bounded by Guadalupe Street on the west and Speedway on the east. In 1921, the legislature appropriated $1.35 million to expand the campus farther to the east. (Published by Sauter and Kuehne, Austin.)

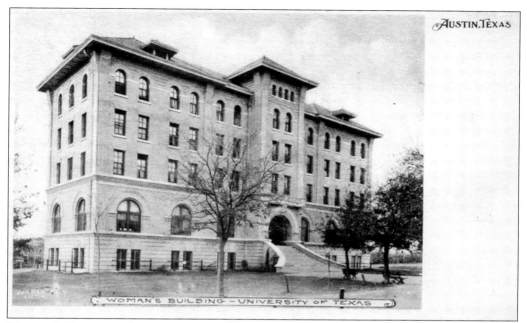

WOMAN'S BUILDING — UNIVERSITY OF TEXAS

WOMAN'S BUILDING (UNDIVIDED BACK). One of the early buildings on campus (1903) is the five-story Woman's Building, occupied as a women's dormitory. It became the drama building in 1955. Next to the building was a wooden shack known as the Women's Gymnasium, later to be reconstructed as the Ann Hiss Gymnasium. (Publisher unknown.)

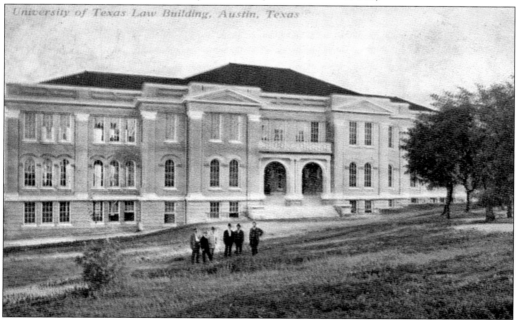

University of Texas Law Building, Austin, Texas

LAW BUILDING. One of the other early building on campus was the Law Building (1908) housing the law school, located adjacent to what would become the Main Mall south of Old Main. It was later replaced by Pearce Hall (1955), then later still by Townes Hall and Jesse H. Jones Hall. The old Law Building was razed in 1972. (Publisher unknown.)

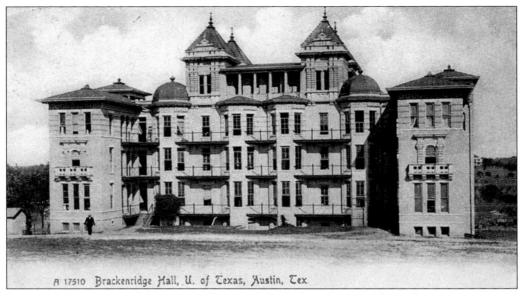

A 17510 Brackenridge Hall, U. of Texas, Austin, Tex

BRACKENRIDGE HALL (UNDIVIDED BACK). A Texas Constitutional Amendment was approved by voters in 1930 to allow the university regents to borrow $4 million from the Permanent University Fund to be used for erecting buildings at UT. Constructed first were buildings for a library, physics, home economics, engineering, architecture, the Student Union, and the men's dormitory—Brackenridge Hall (1932), known affectionately as "B Hall." (Published by the Rotograph Company, New York.)

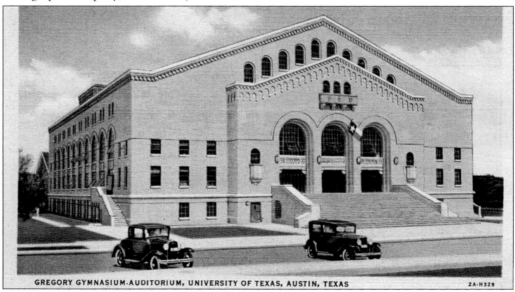

GREGORY GYMNASIUM-AUDITORIUM, UNIVERSITY OF TEXAS, AUSTIN, TEXAS 2A-H329

GREGORY GYMNASIUM. The gymnasium (1930) is named for Thomas Watt Gregory, one of the first 13 graduates of the University of Texas, who received his bachelor of laws degree in 1885. He was later named attorney general of the United States. Gregory raised the funds for the recreational center. Just days before the inaugural Texas-A&M basketball game came word that Gregory Gymnasium was not quite finished. The game was played at Austin High School instead. (Published by Ellison, Austin.)

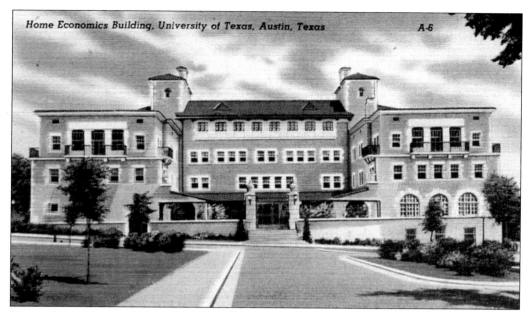

HOME ECONOMICS. Originally called Gearing Hall, the building was constructed in 1933 as part of the Permanent University Fund (PUF) appropriation. It later became the home of the home economics department. Originally home economics was housed in an area known as "a wilderness of shacks"—two dozen unpainted wooden structures—at Nineteenth and Guadalupe Streets. (Published by Hausler-Kilian Cigar and Candy Company, Austin.)

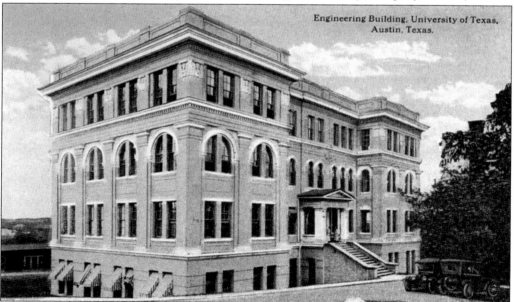

Engineering Building, University of Texas, Austin, Texas.

ENGINEERING BUILDING. The original Engineering Building (1932) was located just east of Old Main and was also part of the PUF appropriation of funds. It later became somewhat of a chameleon, changing from an engineering to a journalism to a speech building. Later a major new engineering complex would be built at Speedway and Twenty-ninth Street. (Published by Abe Frank, Austin.)

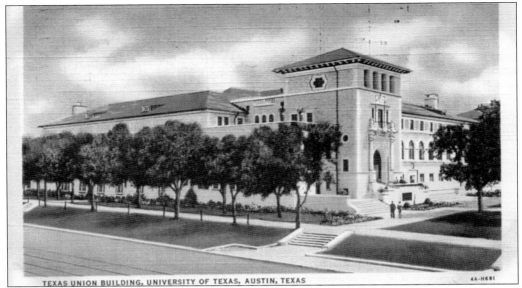

TEXAS UNION BUILDING, 1933. Also known as the Student Union, it houses meeting rooms, an auditorium, the Cactus Café, food services, billiards, and even a bowling alley. The Texas Union was one of three buildings proposed by Thomas Watt Gregory and for which he volunteered to raise funds. The other buildings were Gregory Gymnasium and a women's gymnasium (Anna Hiss Gymnasium). (Published by Ellison, Austin and Curt Teich and Company, Chicago.)

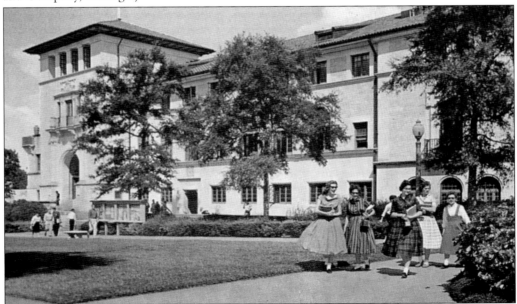

TEXAS STUDENT UNION, 1950S (MODERN CHROME). The building and its uses have not changed, but the style of clothing has through the years. Here a group of collegiate women in hoop skirts congregate outside the student union. Note the oak trees that had been planted earlier are still relatively small. Today these live oaks span completely across the West Mall. (Published by Austin News Agency, Austin.)

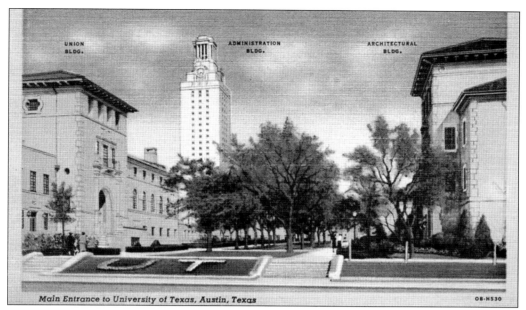

MAIN ENTRANCE TO THE UNIVERSITY OF TEXAS. This postcard views the campus from across Guadalupe Street looking east at what is known as the West Mall, the main entry to the campus. On the left is the Texas Union, on the right the Architectural Building—both very early campus buildings—and in the background are the University Tower and administration building. (Published by Austin News Agency; made by Curteich-Chicago "C. T. Art Colortone.")

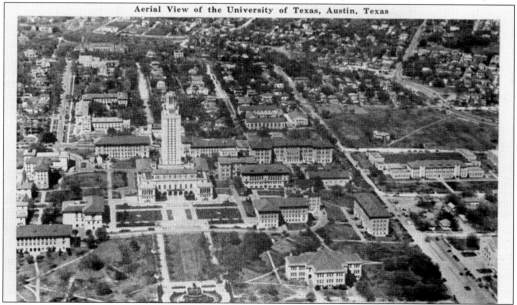

AERIAL VIEW OF THE UNIVERSITY OF TEXAS (WHITE-BORDER CARD). This black-and-white aerial photograph was taken in approximately 1940. By this time, the plaza had been built in front of the tower and the trees planted along the South Mall. The Law Building sits in the foreground, and all of the buildings from the 1930s appropriation had been completed. (Published by Boone, Austin.)

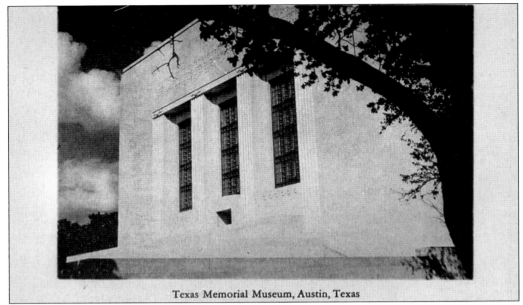

Texas Memorial Museum, Austin, Texas

TEXAS MEMORIAL MUSEUM. The Texas Memorial Museum, situated on the UT campus, was established as part of the Texas Centennial Celebration Bill of 1935, in which funds were allocated for gathering and preparing materials for exhibits. That same year, the U.S. Congress appropriated money for the Texas Centennial Exhibition, $300,000 of which was designated to help pay for the museum building, completed in 1938. (Publisher unknown.)

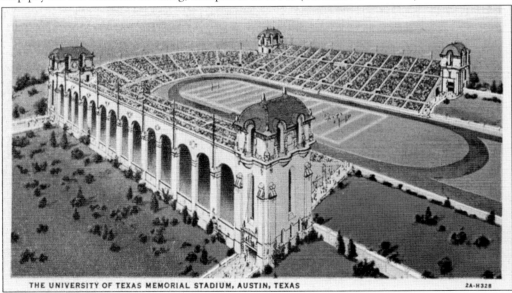

THE UNIVERSITY OF TEXAS MEMORIAL STADIUM, AUSTIN, TEXAS 2A-H328

TEXAS MEMORIAL STADIUM. Constructed in 1924, the stadium was financed through a student-sponsored fund-raising campaign led by athletic director Theo Belmont. Five hundred students raised pledges of $175,000. The citizens of Austin raised an additional $150,000, and alumni added $150,000 more. The stadium was dedicated on Thanksgiving Day 1924. Twenty-seven trains brought visitors from all over the state for the dedication of the 40,000-seat stadium. (Published by Ellison, Austin.)

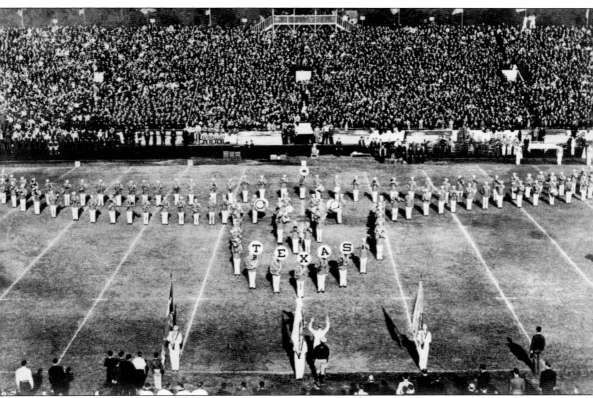

THE UNIVERSITY OF TEXAS BAND. The Longhorn Band was formed in approximately 1900, and in March 1903, students Lewis Johnson and John Lang Sinclair wrote the school song, "The Eyes of Texas" (to the tune of "I've Been Working on the Railroad"). The official fight song, "Texas Fight," was written by Col. Walter S. Hunnicutt along with James King. This real-photo postcard shows the Longhorn Band at Texas Memorial Stadium. (Publisher unknown; Austin History Center, Austin Public Library.)

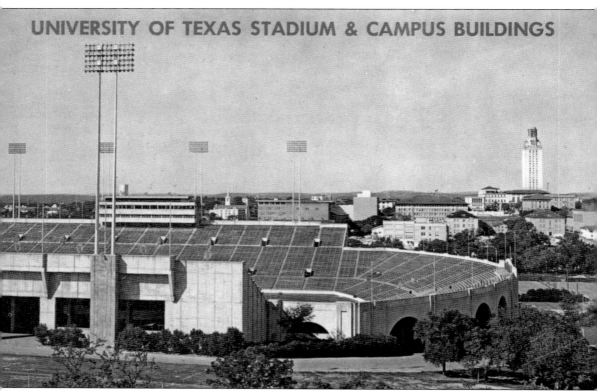

MEMORIAL STADIUM. By the mid–1940s, attendance at Longhorn home football games had grown so much that Texas Memorial Stadium had to be enlarged. In 1948, two sections were added to the stadium's east and west stands, raising seating capacity to 60,000. Texas Memorial Stadium was rededicated on September 18 to honor Texans who had died in World War II. In future years, extensive expansions added upper decks to the west, north, and east sides of the stadium. (Published by Austin News Agency, Austin.)

Six

THE COLORADO RIVER

SCENE ON THE COLORADO RIVER (UNDIVIDED BACK). The Colorado River has been a major feature of Austin since the town's early settlement along its banks in 1839. The early founders prized the pristine area's "beauty of scenery," "graceful woodlands," and the river, streams, and springs of "pure water." But the river brought floods and devastation, too. In the 1890s, city promoters began schemes to harness the river to produce cheap power and create a recreational lake. Others (unsuccessfully) attempted to bring steamboat transportation up the river from the Gulf Coast. Over the succeeding years, the Colorado River shaped much of the city's destiny as well as its ambience. (Published by Sauter and Huehns, Austin, publisher.)

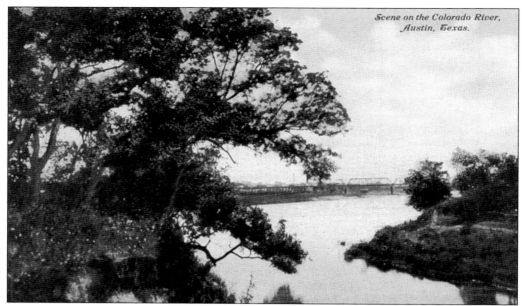

Scene on the Colorado River, Austin, Texas.

SCENE ON THE COLORADO RIVER. Looking downstream toward the city of Austin, a downtown railroad trestle bridge can be seen in the distance. The Colorado River, flowing some 600 miles, is the largest river wholly in Texas, and is not to be confused with the much larger western Colorado River of the Grand Canyon. The river could be highly destructive at times until it was finally tamed in the 1930s. (Published by S. H. Kress and Company.)

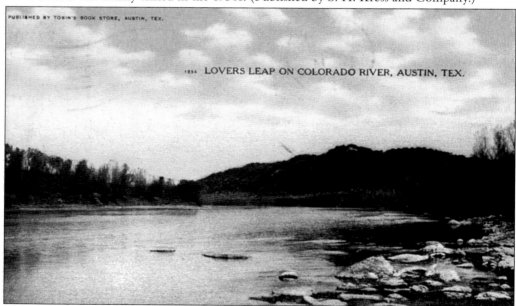

PUBLISHED BY TOBIN'S BOOK STORE, AUSTIN, TEX.

LOVERS LEAP ON COLORADO RIVER, AUSTIN, TEX.

LOVERS LEAP ON THE COLORADO RIVER. This postcard looks upstream along the Colorado River toward what was then called "Lovers Leap" or sometimes "Antoinette's Leap"—a location known today as Mount Bonnell—in memory of a woman who allegedly jumped to her death to escape Native Americans who had just killed her fiancé. Mount Bonnell was a favorite day trip from Austin for its scenic beauty. (Published by Tobin's Books Store, Austin.)

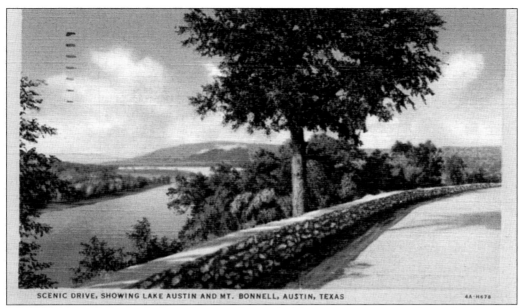

SCENIC DRIVE, SHOWING LAKE AUSTIN AND MT. BONNELL, AUSTIN, TEXAS 4A-H678

MOUNT BONNELL. Mount Bonnell is one of Austin's oldest tourist attractions, being documented as far back as 1850. It was named for George Bonnell, who served as the commissioner of Indian Affairs for the Texas Republic. At the time of the Republic, the other side of the Colorado River was considered Native American territory and unsafe for travel. (Published by Austin News Agency; Curteich, Chicago.)

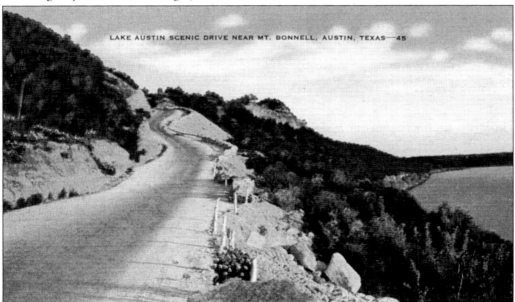

LAKE AUSTIN SCENIC DRIVE NEAR MT. BONNELL, AUSTIN, TEXAS—45

REST STOP AT MOUNT BONNELL. Today the favorite hiking spot is part of Covert Park, a city park named in honor of George Covert, who provided the land to the city. The park is free to the public, and there is a pavilion at the top to rest and take in the view. It is generally considered to be the highest point in Austin (at 775 feet above sea level). (Published by Austin News Agency, Austin.)

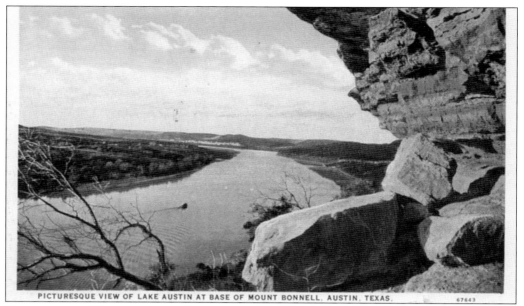

PICTURESQUE VIEW OF LAKE AUSTIN AT BASE OF MOUNT BONNELL. AUSTIN, TEXAS. 67643

PICTURESQUE VIEW OF LAKE AUSTIN. In this and the preceding postcards, this portion of the Colorado River is also known as "Lake Austin"—the lake being formed by the dam several miles east of Mount Bonnell. The dammed river creates a lake that meanders for some 20-plus miles to the west and was planned to keep the river at a relatively constant level. (Published by Abe Frank, Austin.)

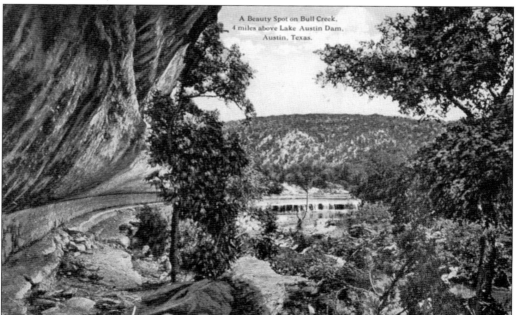

BULL CREEK. Described as "A Beauty Spot on Bull Creek 4 miles above Lake Austin Dam," this location today is approximately where Bull Creek crosses RR 2222, near the County Line on the Lake restaurant, along Lakewood Drive. There is a low water crossing at the entry to Bull Creek District Park at just this spot. (Published by Abe Frank, Austin.)

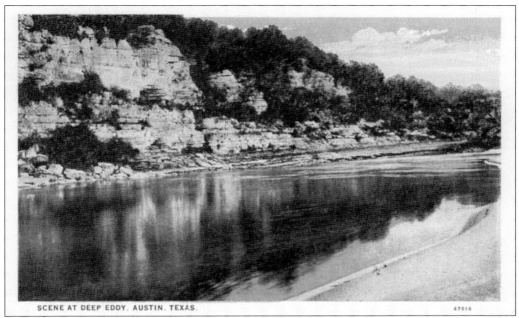

SCENE AT DEEP EDDY, AUSTIN, TEXAS. 47516

DEEP EDDY. A very popular spot along the Colorado River was, and still is, Deep Eddy—a location where the underwater rock formations create a deep pool, later diverted and built into a popular swimming pool as well. In the early days of Austin, this was a close-in spot for cooling off on hot summer days, located just west of downtown. (Published by Abe Frank, Austin.)

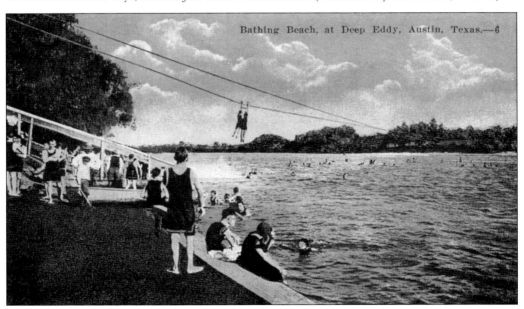

Bathing Beach, at Deep Eddy, Austin, Texas.—6

BATHING BEACH AT DEEP EDDY. Deep Eddy was developed in the early 1900s with both high and low diving boards, a slide, and even a trolley. Here two riders use the trolley, taking them far out into the river. A 1928 parks plan by the city provided for an elaborate system of parks, including construction of the Deep Eddy and Barton Springs pools. (Publisher unknown; Austin History Center, Austin Public Library.)

103

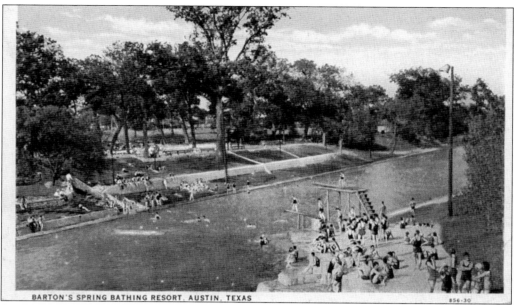

BARTON'S SPRING BATHING RESORT, AUSTIN, TEXAS

BARTON'S SPRING. Barton's Spring is one of the most enduring icons of Austin and a cherished symbol of Austin's quality of life. The three-acre pool is spring-fed (it is the fourth largest spring in Texas), and the water remains a constant 68 degrees year-round. For thousands of years, the springs were a gathering place for Native Americans, and the Spanish explorers wrote about stopping there as well. (Published by C. T. American Art.)

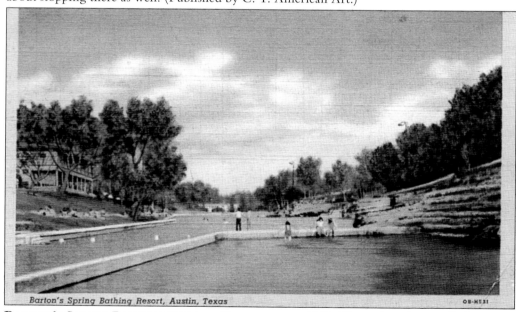

Barton's Spring Bathing Resort, Austin, Texas

BARTON'S SPRING BATHING RESORT, POSTMARKED 1943. The springs (now called "Barton Springs") were named after William "Uncle Willie" Barton, who owned a sawmill as well as flour and gristmills using the power of the water. The largest of the springs pumps an estimated 27 million gallons of water per day. The springs are located in Zilker Park, southwest of downtown. (Published by Austin News Agency; Curteich C. T. Art-Colortone.)

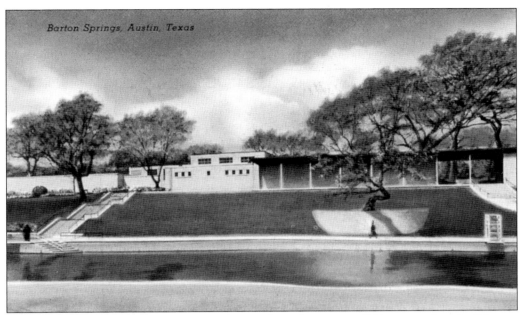

BARTON SPRINGS AND BATHHOUSE. The text from the reverse of this postcard reads, "Barton Springs located in beautiful Zilker Park in Austin, Texas is the most widely known swimming pool in Texas. The beautiful new bath house constructed and operated by the city of Austin adds much to the beauty of the park and pool." (Published by Austin News Agency, Austin.)

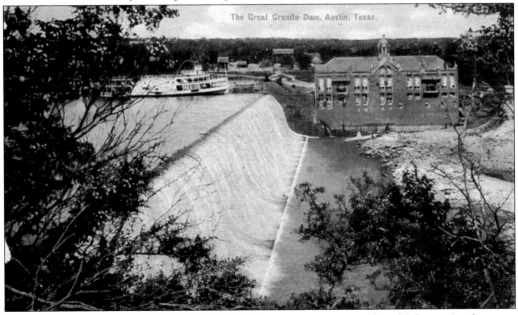

THE GREAT GRANITE DAM, POSTMARKED 1910. In 1895, a 60-foot-high granite dam was built on the Colorado, forming Lake McDonald (later called Lake Austin). The purpose was to generate electricity for Austin's moon towers and hopefully to attract manufacturers who would use the water power and the cheap electricity. The powerhouse is located to the right. On the left is the *Ben Hur* paddleboat. (Published by Abe Frank, Austin.)

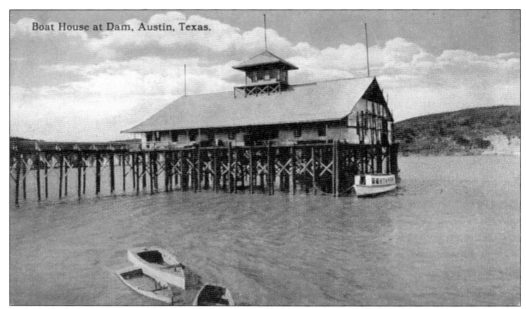

Boat House at Dam, Austin, Texas.

BOAT HOUSE AT DAM. The dam and Lake McDonald were a huge success with the Austin citizenry, and a special railcar brought visitors to the site. A pavilion and grandstand were erected for outdoor summer events when the downtown opera houses were too hot. Sailboats, rowboats, and steam–driven paddleboats plied the waters. Resort property and cottages dotted the shoreline. Lake McDonald extended some 20 miles back from the dam. (Publisher unknown.)

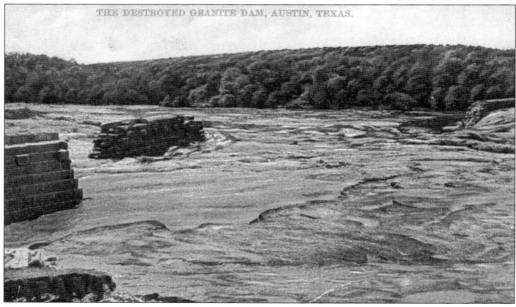

THE DESTROYED GRANITE DAM, AUSTIN, TEXAS.

THE DESTROYED GRANITE DAM, POSTMARKED 1909. In 1899, the lake level dropped precipitously and power was cut short. By late January, the power was cut off to the moon towers, and by March, the water level was nearly 10 feet below the top of the dam. Residential customers were told to rely on candles and oil lamps for light. But just one year later, in 1900, disaster struck. (Published by Abe Frank, Austin.)

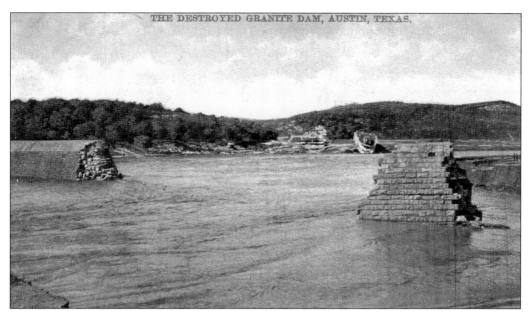

THE DESTROYED GRANITE DAM, AUSTIN, TEXAS.

THE DESTROYED DAM. At 4:30 a.m. on April 6, it began to rain, and it continued to rain hard for 24 hours. Shoal Creek flooded its banks, washing away several homes. An 11-foot-high level of water rose above the 60-foot-high dam until suddenly the dam itself burst. This April 10, 1900, photograph is from below the dam, taken four days later. (Published by Abe Frank, Austin; Waneen Spirduso collection.)

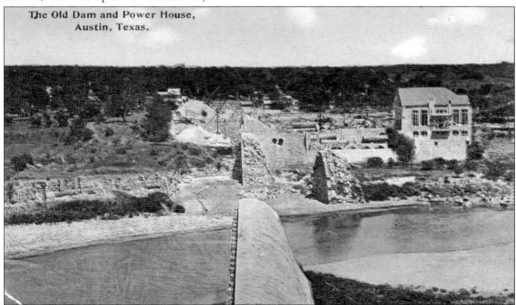

The Old Dam and Power House, Austin, Texas.

OLD DAM AND POWERHOUSE. As the dam burst, portions of the powerhouse were flooded or washed away entirely, killing eight people. The wall of water swept downstream and into the city of Austin, washing away houses, barns, and animals in its path. People rushed to the lower end of Congress Avenue to witness the destruction. Austin found itself without water or power. (Published by Sauter and Kuehne, Austin.)

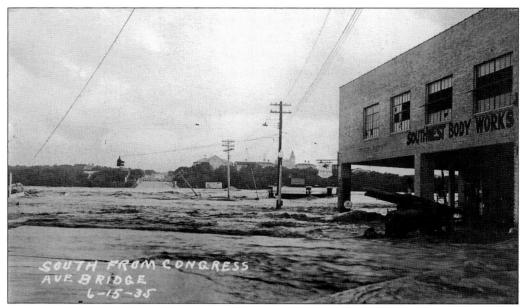

THE 1935 FLOOD (RPPC). The 1900 and 1935 floods were devastating to the area around the Congress Avenue Bridge, flooding both the north and south shore of the Colorado. This photograph looks south across the Colorado River at the location of the Congress Avenue Bridge during the 1935 flood. A Mobil station and body works garage are on the right. (Real-photo postcard; Waneen Spirduso collection.)

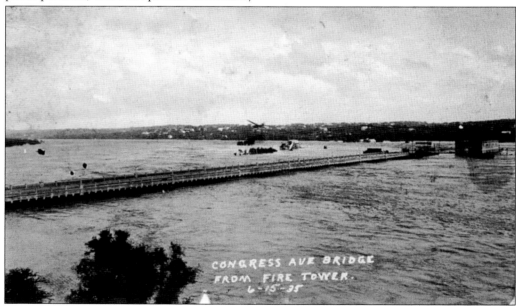

CONGRESS AVENUE BRIDGE. The wooden Congress Avenue Bridge was destroyed in the 1900 flood but was rebuilt 15 years later with concrete arch supports. By the time of the 1935 flood, the bridge held firm. This real-photo, undivided-back postcard from June 15, 1935, shows how the level of the flood did not cover the bridge itself, although the approaches to the bridge were flooded. (Real-photo postcard.)

DESTRUCTION OF THE GREAT GRANITE DAM. Investigation revealed that the cause of the 1900 destruction included sediment that had built up behind the dam and water seeping around the structure. Apparently the designer had tried to warn the city leaders of improper structural changes made on-site during construction, but he was ignored. The city tried to rebuild the dam twice but ran out of money to complete the project. (Publisher unknown.)

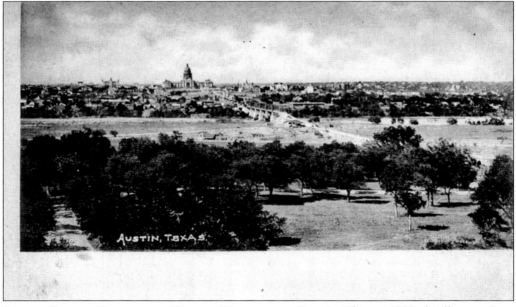

SOUTH SHORE COLORADO RIVER (UNDIVIDED BACK). This *c.* 1890s bird's-eye view, looking north across the river, shows early construction in Austin. The capitol rises on the horizon, and in the far distance to the left can be seen the University of Texas Old Main Building. The Congress Avenue Bridge seen here is the wooden bridge that was washed away in the April 1900 flood. (Published by Tobin's Book Store, Austin.)

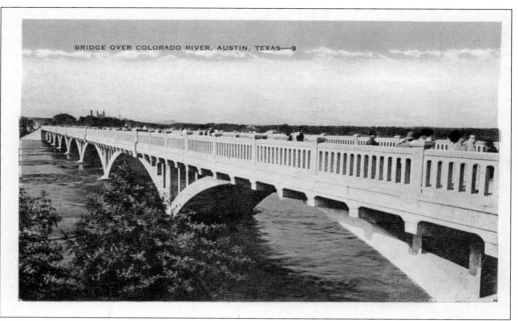

CONGRESS AVENUE BRIDGE. This *c.* 1925 view shows the permanent concrete-arch structure that survives to this day. Typeset on the back of the card notes that the bridge "spans the same spot where 'thundering herds' of cattle crossed as they were driven to northern markets in the 1860s." (Published by E. C. Kropp Company, Milwaukee.)

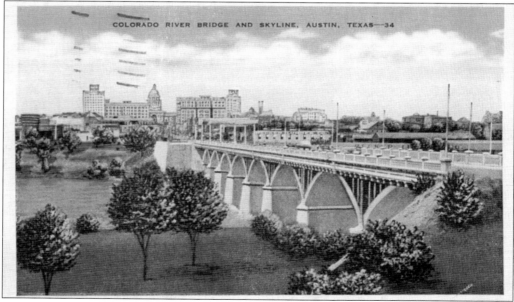

COLORADO RIVER BRIDGE. The first crossing of the Colorado River was a pontoon bridge that quickly washed away. A newer wooden bridge washed away in the 1900 flood, and it was 10 years before a new bridge was even attempted. This concrete-arch bridge showed its worth, withstanding the devastating 1935 flood and still standing today, renamed the Ann W. Richards Bridge in 2006. (Published by E. C. Kropp Company, Milwaukee.)

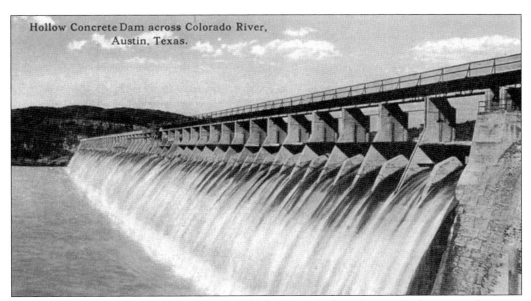

Hollow Concrete Dam across Colorado River, Austin, Texas.

THE HOLLOW CONCRETE DAM. It would be years before the original granite dam was permanently replaced with a modern concrete dam. Thanks in great part to the legislative maneuvering of then-congressman Lyndon B. Johnson, a new dam was completed in 1940 (later renamed Tom Miller Dam for the popular mayor) by the newly formed Lower Colorado River Authority (LCRA). The lake behind the dam was officially named Lake Austin. (Published by Abe Frank, Austin.)

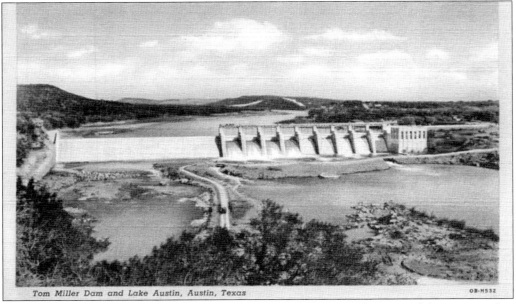

Tom Miller Dam and Lake Austin, Austin, Texas OB-H532

TOM MILLER DAM. Tom Miller Dam was possible in large part because of the construction of a much larger dam upstream, the Mansfield Dam, which was almost three times bigger than the Tom Miller Dam. Miller Dam provided enough electricity for existing Austin as well as power that allowed Austin to grow significantly. It also provided a dependable water supply. (Published by Austin News Agency; C. T. Art-Colortone.)

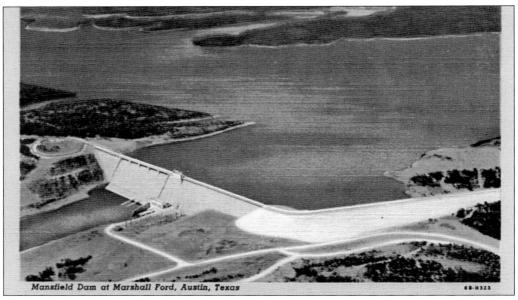

Mansfield Dam at Marshall Ford, Austin, Texas &B-N323

MANSFIELD DAM AT MARSHALL FORD. Lyndon Johnson also got Congress and President Roosevelt to back an astounding $10-million dam at Marshall Ford called Mansfield Dam. The LCRA-constructed dam formed an enormous flood-control basin in the form of Lake Travis, which was designed to hold a massive amount of water in times of floods. To date, the dam has never been topped. (Published by Austin News Agency; C. T. Art-Colortone.)

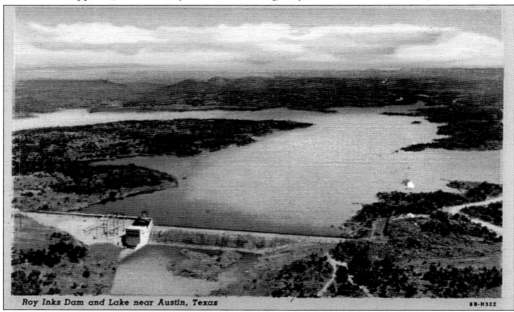

Roy Inks Dam and Lake near Austin, Texas &B-N322

ROY INKS DAM. A series of six dams and reservoirs, owned and operated by the LCRA, together form the Highland Lakes chain that tamed the Colorado River. Inks Lake is between the towns of Burnet and Llano and is bordered on one side by a state park. The concrete dam, completed in 1938, forms a constant level lake below the Buchanan Dam. (Published by Austin News Agency; C. T. Art-Colortone.)

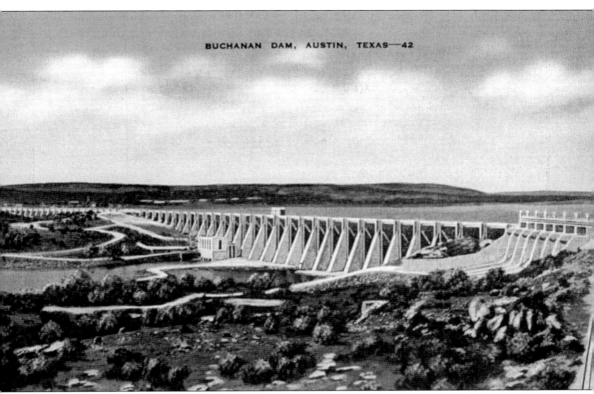

BUCHANAN DAM. The furthest west among the Highland Lakes chain is Buchanan Dam, a massive flood-control facility on the south shore of Lake Buchanan. A private contractor was hired to build the dam and soon set up camp for several hundred workers, a post office, and necessary support and medical facilities. After the company went bankrupt, Congressman James P. Buchanan secured the federal funds to finish the project. (Published by Austin News Agency, Austin.)

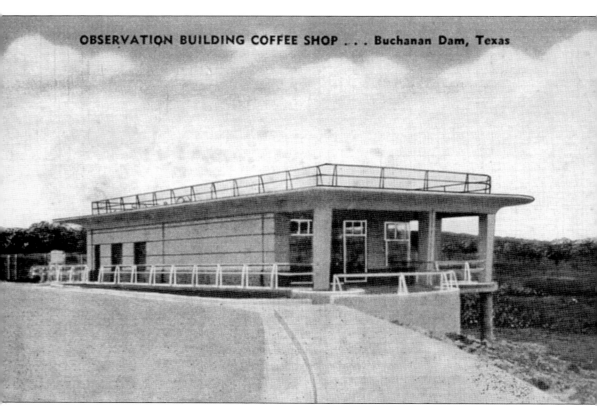

OBSERVATION BUILDING COFFEE SHOP . . . Buchanan Dam, Texas

OBSERVATION BUILDING AND COFFEE SHOP. An "Ultra Modern Air Conditioned Restaurant specializing in juicy steaks" was set up in an observatory overlooking Lake Buchanan, created by the Lower Colorado River Authority for the convenience of the traveling public. The observatory still exists today as part of a museum depicting the Highland Lakes. The dam, located 66 miles northwest of Austin, was completed in 1937. (Published by R. C. Shaul, Chicago.)

Seven

Motels and Hotels

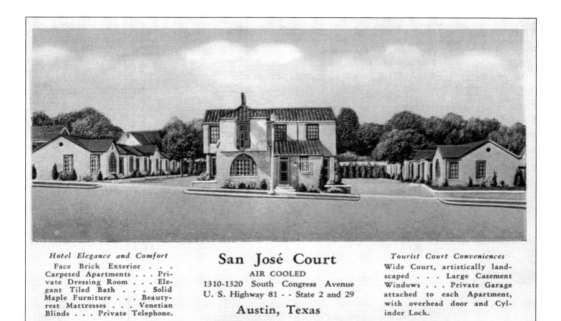

Hotel Elegance and Comfort
Face Brick Exterior . . .
Carpeted Apartments . . . Private Dressing Room . . . Elegant Tiled Bath . . . Solid Maple Furniture . . . Beautyrest Mattresses . . . Venetian Blinds . . . Private Telephone.

San José Court
AIR COOLED
1310-1320 South Congress Avenue
U. S. Highway 81 - - State 2 and 29

Austin, Texas

Tourist Court Conveniences
Wide Court, artistically landscaped . . . Large Casement Windows . . . Private Garage attached to each Apartment, with overhead door and Cylinder Lock.

SAN JOSE COURT. Numerous quaint, small motels served the traveling public in Austin in the 1930s, 1940s, and 1950s, but hardly any remain today. One notable exception is the San Jose Court—now the Hotel San Jose—on South Congress Avenue, south of the Colorado River. Today Hotel San Jose is a highly successful chic retro throwback to the days gone by. Here is how it looked originally. (Published by E. C. Kropp Company, Milwaukee.)

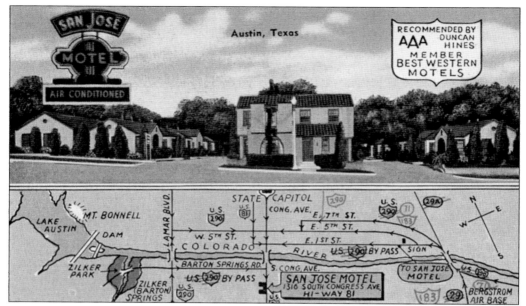

SAN JOSE MOTEL. This additional San Jose postcard provided illustrated directions to the motel. Note how the highway names were subsequently changed and updated. The card reads: "1316 So. Congress—Highway 81. Close to everything—Brick exterior—Carpeted rooms—Tiled baths—Phones—Vented heat—Air cooled and Air conditioned." (Published by E. C. Kropp Company, Milwaukee.)

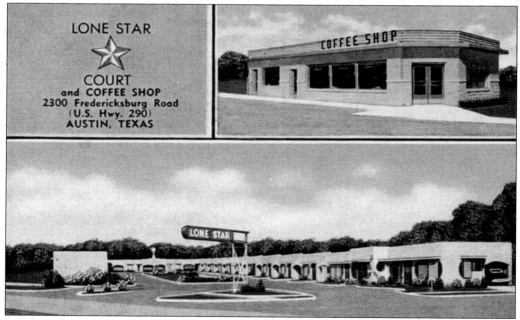

LONE STAR COURT AND COFFEE SHOP. The Lone Star Court and Coffee Shop could boast: "Within city limits—City Bus Service—Free Radios—Coffee Shop—Room Service—Telephones—Tile Showers—Carpeted Floors—Every Convenience for your Comfort." (Published by R. C. Shaul, Chicago.)

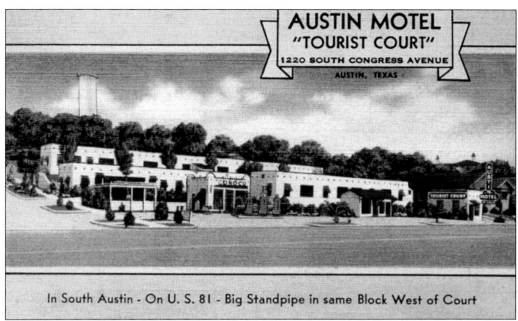

AUSTIN MOTEL
"TOURIST COURT"
1220 SOUTH CONGRESS AVENUE
AUSTIN, TEXAS

In South Austin - On U. S. 81 - Big Standpipe in same Block West of Court

Austin Motel "Tourist Court." Still a beloved destination for lodging and now the attached El Sol y La Luna restaurant, the Austin Motel has seen growth, decline, and growth again as it now finds itself right in the middle of one of the most popular areas of Austin: South Congress Avenue. The motel has kept the iconic Austin Motel landmark neon sign that was erected along with the hotel in 1938 by Jennie and Earnest Stewart. The front of this card reads, "At 1220 South Congress Avenue. In South Austin—On U.S. 81—Big Standpipe in the same Block West of Court." The reverse side reads, "The Beautiful Court of Service and Comfort. 2 minutes from downtown. Telephones—Kitchenettes—Café—AAA—Traveling Men's Association of Texas, Inc." (Publisher unknown.)

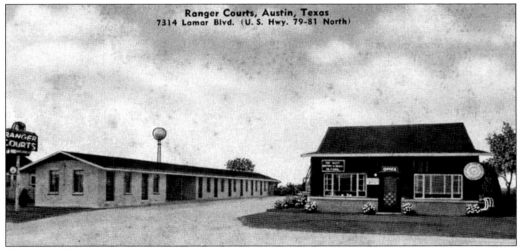

Ranger Courts, Austin, Texas
7314 Lamar Blvd. (U. S. Hwy. 79-81 North)

Ranger Courts. Once considered on the outskirts of town, the Ranger Courts advertised itself as: "7314 Lamar Blvd (U.S. Hwy 79-81 North). Vented Heat—Air Cooled—Tile Baths—Excellent Beds. Phone 5-1375." (Published by R. C. Shaul, Chicago; made by E. C. Kropp Company, Milwaukee.)

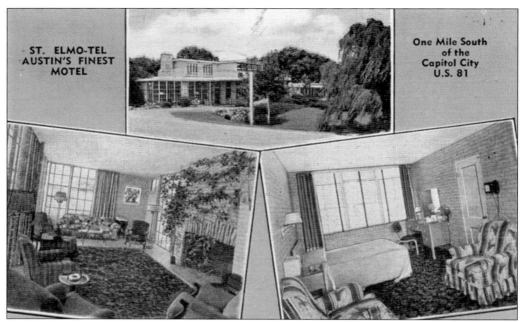

ST. ELMO-TEL
AUSTIN'S FINEST
MOTEL

One Mile South
of the
Capitol City
U.S. 81

ST. ELMO-TEL. AUSTIN'S FINEST MOTEL. Although it may not have been Austin's "finest motel," St. Elmo-Tel was perched close to Austin and told visitors so on its card: "4501 So. Congress—Highway 81. One Mile South of the Capitol City. Modern Rooms, each with private tile bath, telephone, radio, car shelter. P.O. Box 871, Austin, Texas. Phone: 8-1666." (Published by E. C. Kropp Company, Milwaukee.)

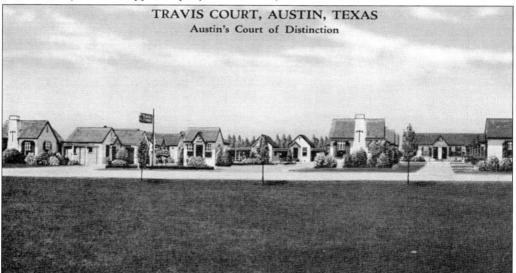

TRAVIS COURT, AUSTIN, TEXAS
Austin's Court of Distinction

TRAVIS COURT—AUSTIN'S COURT OF DISTINCTION. If only the cost to stay in a motel was still $1.50–$2 per person. This card reads, "Travis Court is located ½ mile north of the city limit on U. S. Hwy 81, upon a much higher elevation than the city, therefore, away from the noise, dust and heat of the city. The 29 units are of the latest design and have facilities and furnishings that will please the most fastidious. RATES: Two persons, $1.50 to $2.00. (Published by E. C. Kropp Company, Milwaukee.)

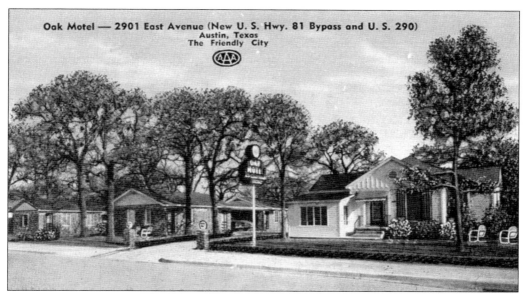

Oak Motel — 2901 East Avenue (New U. S. Hwy. 81 Bypass and U. S. 290)
Austin, Texas
The Friendly City

OAK MOTEL. It is interesting to note how telephone exchanges used to be shorter; take note of the telephone number at the end of this card's description: "2910 East Avenue (New U.S. Hwy 81 Bypass, Dallas to San Antonio and U.S. 290, El Paso to Houston) Austin, Texas. Carrier Air Conditioned—Vented Panel Ray Heat—Family Cottages—Three Minutes from Center of City. Owned and Operated—Mr. and Mrs. L. C. Johnson. Phone 6-9597." (Published by R. C. Shaul, Chicago.)

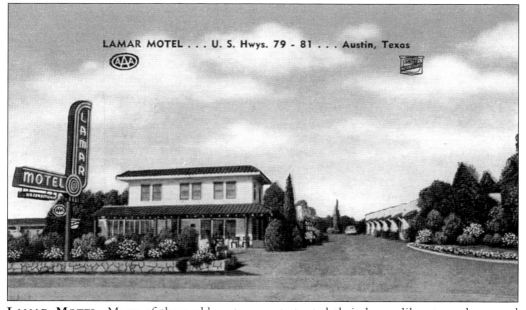

LAMAR MOTEL . . . U. S. Hwys. 79 - 81 . . . Austin, Texas

LAMAR MOTEL. Many of these old motor courts touted their home-like atmospheres and also included attached garages for travelers' vehicles: "Lamar Motel . . . U. S. Hwys. 79—81 (north) . . . Austin, Texas . . . Steam Heated—Air Conditioned—Full Tile Bath—Beauty-Rest Mattresses—telephone—Garages. P.O. Box 4145. Phone 8-5753." (Published by R. C. Shaul, Chicago; made by E. C. Kropp Company, Milwaukee.)

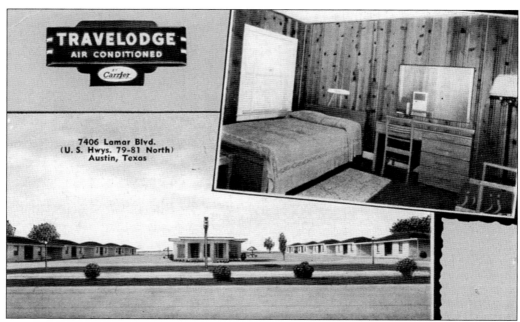

TRAVELODGE. "'For Those Who Care' Air Conditioned by Carrier. Austin's Newest and Finest. 7406 Lamar Blvd (U. S. Hwys 79-81 North) Austin, Texas Phone 5-5421," reads the text on the card. Which begs the question: what did the Ranger Courts down the street think of such bold advertising? (Publisher unknown.)

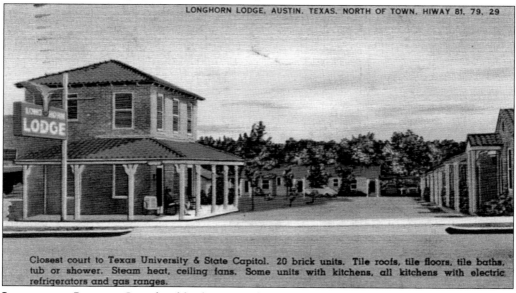

LONGHORN LODGE. One should take note of the way "highway" was then abbreviated and how the University of Texas was called Texas University by the Longhorn Lodge: "North of Town. Hiway 81, 79, 29. Closest court to Texas University & State Capitol. 20 brick units. Tile roofs, tile floors, tile baths, tub or shower. Steam heat, ceiling fans. Some units with kitchens, all kitchens with electric refrigerators and gas ranges." (Published by Colorpicture, Cambridge, Massachusetts.)

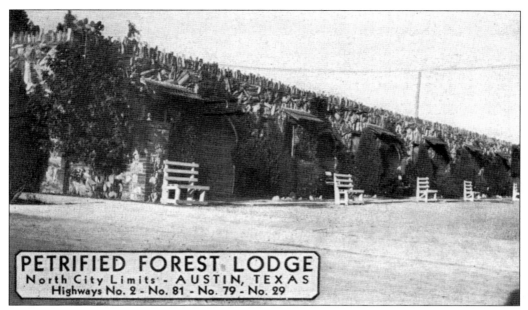

PETRIFIED FOREST LODGE. The card description reads: "North City Limits—Austin, Texas. Highways No. 2—No. 81—No. 79—No. 29 North City Limits, Austin Texas. 4505 Guadalupe." The remains of this motel were recently razed and replaced with a Walgreen's, which helpfully incorporated some of the petrified wood into the store's exterior design. (Published by Hitt Card Company, Hollywood.)

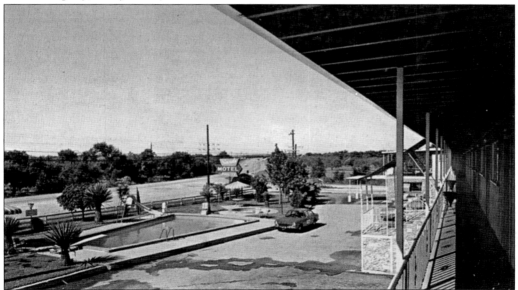

SANDS MOTEL. Interestingly, the Sands Motel still exists and rooms are rented on a weekly and monthly basis. When it first opened, however, one could take advantage of its touted amenities: "Relax in our spacious individually controlled air conditioned and heated rooms . . . free TV . . . filtered swimming pool . . . easy access to downtown and all recreational facilities . . . special family rates . . . owner operated. 4701 S. Lamar—Hwy 290 West." (Published by Dorf Photography, Austin.)

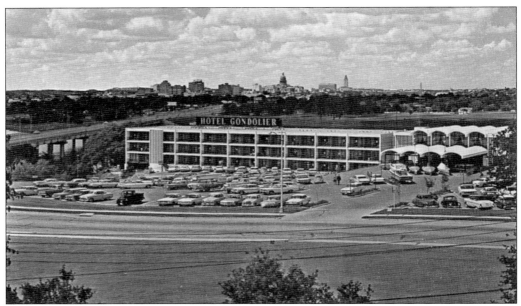

THE GONDOLIER MOTOR HOTEL. Perhaps one of the more interesting motels/hotels in Austin was the Gondolier (later a Sheraton Hotel). The hotel actually offered simulated gondola rides on Town Lake. It highlighted its location with the description: "Located on the shores of Town Lake in downtown Austin, just five minutes from the Texas State Capitol, State Office Buildings and Austin's fabulous new Auditorium and Convention Center and the University of Texas campus. Boat Rides—Fishing—Swimming Pool. 125 rooms with T.V., Music and Radio." The hotel, located on the northeast corner of Interstate 35 and Riverside Drive, was later turned into UT student housing for several years, then a limited-service hotel, and was eventually shuttered. In 2008, the abandoned hotel was razed for construction of a high-rise condominium project. (Both published by Hannau-Robinson Color Productions, Inc., Houston.)

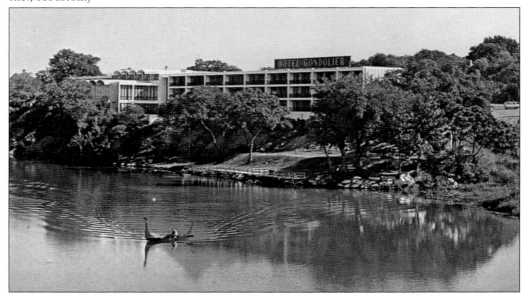

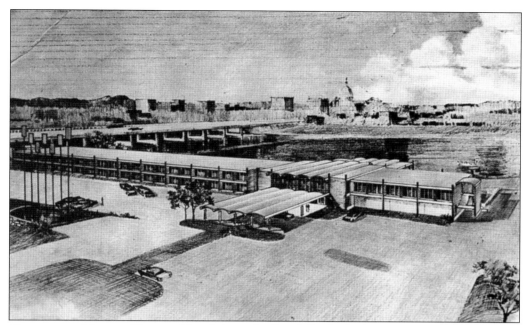

GONDOLIER MOTOR HOTEL. Here is how the Gondolier looked in an artist's rendering of its original incarnation at its opening. A third story was added some years later, as can be seen on the previous two postcards. Even from the beginning, the hotel featured gondola rides on Town Lake. (Published by Hannau Color Productions, Houston.)

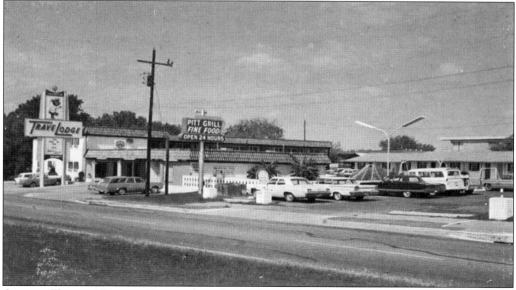

AUSTIN TRAVEL LODGE. It must have been nice not to have to worry about paying extra to watch television: "4800 North Interregional Hwy. 35. Air-Conditioned Units . . . parking at your door . . . free TV . . . swimming pool . . . children's playground . . . 24-hour coffee shop . . . coin-operated laundry . . . free pickup and delivery to the Municipal airport . . . owner operated. Ph GL 2-9494." (Published by Nationwide Advertising Specialty Company, Dealer, F. Horsfall, Austin.)

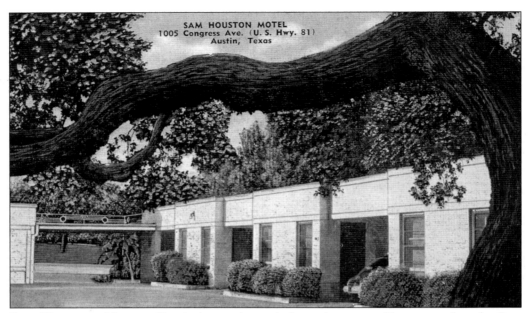

SAM HOUSTON MOTEL. Proximity to the capitol was important if one stayed at the Sam Houston: "Located on The Most Beautiful Entrance to Any State Capitol in the United States. No tips, No Garage Expenses, Air conditioned in Summer, Steam heat in Winter, Hot and Cold Showers, Phones in Each Room, Modern Throughout, Maid Service, Ph 8-1641." (Published by E. C. Kropp Company, Milwaukee; Waneen Spirduso collection.)

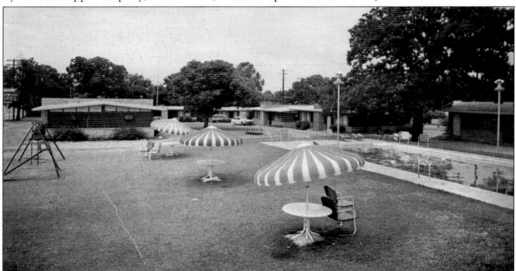

RIDGEWOOD MOTEL. Note how the telephone number changed with time. One then had to dial the number incorporating the first two letters of the word "Homestead." The Ridgewood advertised itself as follows: "4600 East Avenue, on North Expressway 81. Beautifully situated in a setting of oak trees just a few seconds from downtown Austin. All units refrigerated air-conditioned, vented heat, room phones, wall-to-wall carpet, television and triple-filtered swimming pool. Large family rooms. Eating facilities near-by. Phone Homestead 5-6760." (Published by Don R. Bartels, McAllen.)

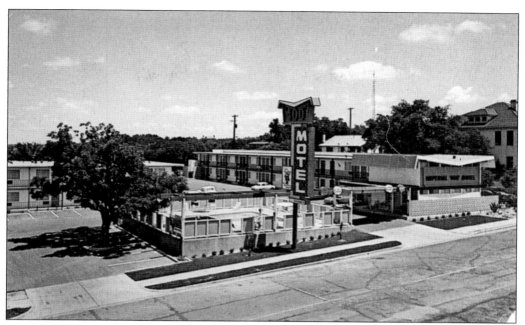

IMPERIAL 400 MOTEL. In 2007, this motel was turned into trendy art deco boutique shops, including fashionable women's clothing and an Amy's Ice Cream store. The card reads, "Imperial '400' Motel, 901 South Congress Ave., Austin 13, Texas. Colored TV, Phones—Air Condition Rooms. Near Municipal Auditorium, Univ of Texas, Town Lake." (Publisher unknown.)

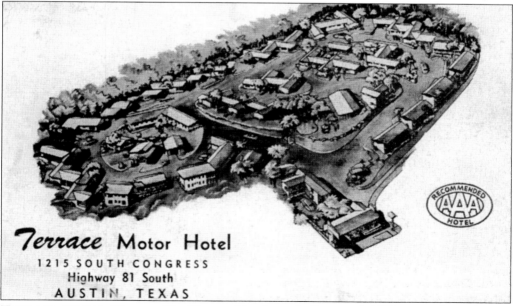

Terrace Motor Hotel

1215 SOUTH CONGRESS
Highway 81 South
AUSTIN, TEXAS

TERRACE MOTOR HOTEL. The Terrace Hotel was built around 1950 across from the still popular Austin Motel. Its swimming pool was a must for the sweltering Texas summer. The card reads, "102 beautifully refrigerated air conditioned rooms located only 12 blocks from the heart of the city. Coffee shop and large swimming pool high up on the Terrace. 1215 South Congress. Highway 81 South. Phone 8-9357. Box 723." (Publisher unknown.)

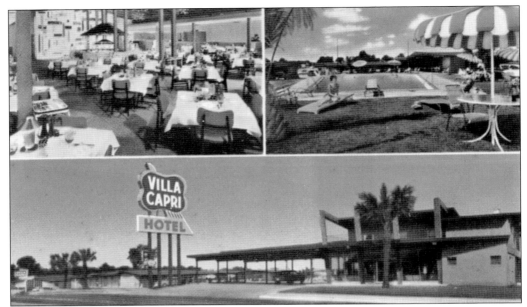

VILLA CAPRI HOTEL. No listing of Austin motels and hotels would be complete without the famous Villa Capri. Located on Interstate 35, immediately adjacent to the University of Texas and Texas Memorial Stadium, it was the preferred location for those coming from out of town to UT football games. The hotel was often booked a year in advance by Longhorn alumni, and its dining room was full year-round. Business seminars were often held in the hotel's large meeting rooms. Its passing was an Austin event, when the hotel was eventually razed to make way for an enclosed football practice field—Denius Field. The hotel was advertised as follows: "On U.S. 81 and 290 and Interstate 35 (Memorial Stadium Exit). 275 Rooms and Suites—Completely Air Conditioned—2 Swimming Pools—Restaurant—24 Hour Hotel Service—Display Rooms and Auditorium—Close to Downtown—University of Texas—Capitol—Airport. GR6-6171." (Both published by BELLS, Austin.)

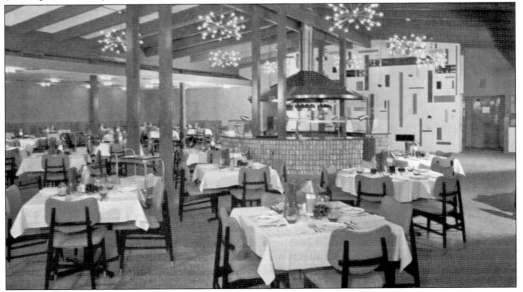

BIBLIOGRAPHY

A Walking Tour Guide of Austin's Historic Congress Avenue and 6th Street. City of Austin, 1995.
www.austin-chamber.org
Barkley, Mary Starr. *History of Travis County and Austin, 1839–1899.* Waco, TX: Texian Press, 1963.
Bateman, Audray. *An Austin Album.* Austin, TX: Encino Press/Friends of the Austin Public Library, 1978.
Berry, Margaret C. *UT History 101.* Austin, TX: Eakin Press, 1997.
www.census.gov
Cox, Mike. *Historic Austin, An Illustrated History.* San Antonio, TX: Historical Network Publishing, 1998.
Douglass, Curran F. *Austin Natural and Historic.* Austin, TX: Eakin Press, 2000.
Humphrey, David C., and William W. Crawford Jr. *Austin, An Illustrated History.* Sun Valley, CA: American Historical Press, 2001.
Kerr, Jeffrey. *Austin, Texas Then and Now.* Austin, TX: Promised Land Books, 2004.
Powell, William Dylan. *Austin Then and Now.* San Diego, CA: Thunder Bay Press/Anova Books Company Ltd., 2006.
Reese, Marisa Hart. *Historic Photos of Austin.* Nashville, TN: Turner Publishing Company, 2006.
The Travis County Courthouse. Travis County Historical Commission, 2001.
www.tshaonline.org/handbook/online/
Werther, Mark, and Lorenzo Mott. *Linen Postcards, Images of the American Dream.* Wayne, PA: Sentinel Publishing, 2002.

Across America, People are Discovering Something Wonderful. *Their Heritage.*

Arcadia Publishing is the leading local history publisher in the United States. With more than 4,000 titles in print and hundreds of new titles released every year, Arcadia has extensive specialized experience chronicling the history of communities and celebrating America's hidden stories, bringing to life the people, places, and events from the past. To discover the history of other communities across the nation, please visit:

www.arcadiapublishing.com

Customized search tools allow you to find regional history books about the town where you grew up, the cities where your friends and family live, the town where your parents met, or even that retirement spot you've been dreaming about.